IMAGES
of America

JACKSONVILLE'S SOUTHSIDE

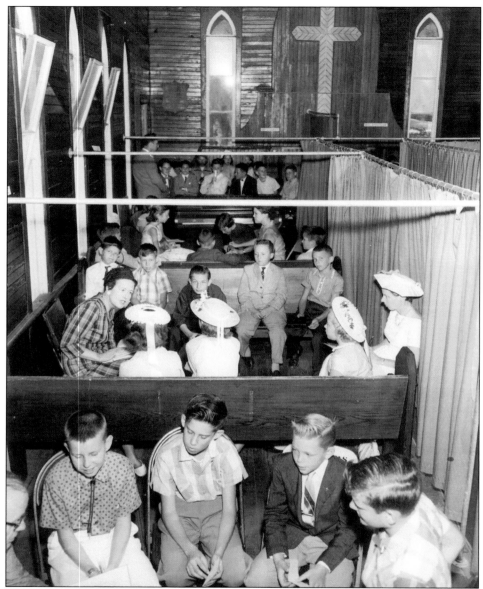

The need for a new building is clear in this 1950s photograph of the interior of St. Paul's small Gothic church building. To accommodate its growing congregation, the pews were sectioned off with drapes to allow for individual Sunday school classes. The students and adults in this photograph are unidentified. The beautiful woodwork and arched windows visible in the background can be seen today in the building at its current location in Fletcher Park. It is owned by the San Marco Preservation Society. (Courtesy of St. Paul's Episcopal Church.)

ON THE COVER: The St. Paul's Episcopal Church congregation is seen here in June 1952 attending a service under the trees. Their small 1880s Carpenter Gothic church building had become inadequate for their growing numbers, so they moved to this shady outdoor area adjacent to the church along Atlantic Boulevard. (Courtesy of St. Paul's Episcopal Church.)

IMAGES
of America

JACKSONVILLE'S
SOUTHSIDE

Debra Webb Rogers

ARCADIA
PUBLISHING

Published by Arcadia Publishing
Charleston, South Carolina

Printed in the United States of America

Library of Congress Control Number: 2011943288

For all general information, please contact Arcadia Publishing:
Telephone 843-853-2070
Fax 843-853-0044
E-mail sales@arcadiapublishing.com
For customer service and orders:
Toll-Free 1-888-313-2665

Visit us on the Internet at www.arcadiapublishing.com

*To Dick, Ken, Tommy, and the Landon Alumni Association
for their help and inspiration; and to my "partners in
crime" for their wonderful friendship and support*

CONTENTS

ACKNOWLEDGMENTS

A book such as this requires the efforts and generosity of many individuals, and without their assistance, this publication would not have been possible. I would like to thank the following people for their contributions and support:

Maggie Bullwinkle, acquisitions editor, Arcadia Publishing
Caitrin Cunningham, acquisitions editor, Arcadia Publishing
Thomas Reeves
Richard Rousseau
Ken and Sharon Peterson
Judy and Mike Downs
Merilyn Chupp Kaufmann, historian, St. Paul's Episcopal Church
Polly Gray, librarian, St. Paul's Episcopal Church
Adam Watson, archivist, State of Florida Photographic Archives
Raymond W. Neil, senior librarian, Florida Collection, Jacksonville Public Library
St. Paul's Episcopal Church
Southside Baptist Church
Margaret Weatherby
Thomas Reeves
The Andrews family
Tom Markham
John Leynes
Cleve Powell
Fred and Lamar Marjenhoff
Gail Haas
Carolyn Knopf Graham
Reid Tillis
Joanne Waits
The Landon Alumni Association
Mary Ann Miller
Wilma L'Engle
Joe Adeeb
Lostparks.com
Terrell Bowman
Robert Williams
Pauline D. Webb
Laura and Mike of Stan's Sandwich Shop
Philip W. Miller
John Landon Webb
Seth Bramson, Florida East Coast Railway historian
Dorothy K. Fletcher
Samuel J. Rogers
Stephen J. Smith, photographer
Gary Roberts of Robert's Southbank Pharmacy
Robert H. Brown

All non-credited photographs are part of the author's personal collection.

INTRODUCTION

The history of Jacksonville's Southside includes stories of bridges, biplanes, ferries, theme parks, movie stars, and silent films. It features tourists, ostriches, industrial complexes, hospitals, trendy housing developments, and insurance giants. However, the story of Southside's past is that of the humble man with uncommon fortitude who settled here and laid down deep roots. Pioneers planted their feet firmly on the sandy soil and forged the beginnings of a vibrant city. Many offspring still own original parcels and live in these communities today.

These early residents included the following: Swedish immigrants, whose native language remains in faded handwriting on the backs of photographs; real estate entrepreneurs, who changed the landscape; Northerners, who fell in love with orange groves and the warmer climate; farmers, who made their living from the soil and neighborhood gardens; fishermen, who sought a living from the water; and alumni of Southside's first high school, many of whom still gather at least once a month to trade stories and reminisce and record the past for future generations.

Southside's story is also one of great change. There was the splendid turn-of-the-century amusement park that struggled to survive, only to succumb to fires that burned it so thoroughly that no remnant remains today in structures or in memory. Philips Highway was once a grand and glorious boulevard that welcomed travelers from the North with its varied selection of accommodations and eating establishments. It is now a weary artery. Many old motels still line the corridor with their swimming pools filled with soil and dirt. Their windows are hidden behind painted, weathered boards used as sheathing. As renovations begin on some, others sit silently watching the traffic pass as if hoping someone will stop and give them an opportunity and a purpose.

Jacksonville's Southside was built upon the ashes of the great fire of 1901 that consumed most of the downtown area on May 3. The conflagration was so great that pieces of the burning city were carried by a southerly wind across the marsh and river to settle on the sandy beach soil that Southside residents walk upon today. That fire inspired the vision of Brightman Skinner, whose epiphany in the pines led to many landmarks we see today: Deerwood, Baymeadows, University of North Florida and Butler Boulevard, and many others.

Bridges were the key that unlocked the area. Spanning the St. Johns River, these critical links provided the means and the catalyst for Jacksonville's expansion southward. By 1898, Henry Flagler's railroad bridge became the first structure to span the St. Johns River in Jacksonville. Until then, and for many decades afterward, ferries provided transportation from one side of the river to the other. The first automobile bridge, built in 1921, was named the St. Johns River Bridge or the Acosta. By the outbreak of World War II in 1941, the John T. Alsop Bridge was complete. Others to follow were the Matthews Bridge in 1953 and the Hart Bridge that same year. The Fuller Warren Bridge was finished in 1954. The links to Southside's growth were now in place.

The bridges did more than open local development. They brought a steady flow of tourists from the North to the South. Vacationing families filled the small "mom-and-pop" motels along Philips Highway and patronized the restaurants, drive-in movies, and theme parks. With the new bridges in place, real estate developments were platted by developers like Telfair Stockton and Percy Mundy, the former animal trainer. Skilled workers brought trades to industrial businesses like Merrill-Stevens Shipyard, the Florida East Coast Railway, Hope Haven Hospital, and Prudential Insurance Company (Prudential settled in Jacksonville after being rejected by Savannah, Georgia).

Each bridge guided its travelers onto one of the following main arteries into Southside Jacksonville: Beach Boulevard, Philips Highway, San Jose Boulevard, Hendricks Avenue, St. Augustine Road, and Atlantic Boulevard, the first beach road. The first growth was along the waterways into areas known as South Shores, St. Nicholas, Philips, South Jacksonville, South Arlington, and Clifton. These names still exist today with streets bearing the following: Merrill, Hendricks, Caljon, and Clifton Avenues, with Clifton meandering along the Arlington River. Clifton was platted out of

the old Kingsley Plantation (Richard land grant) as a failed church retirement resort in the 1870s. Growth increased rapidly after World War II. A ferry named *Clifton* once docked in the area.

The town of South Jacksonville was the forerunner of the community we know today as Southside. South Jacksonville was a separate city until its annexation by the city of Jacksonville in 1932. More subdivisions developed from this growth carrying names such as San Marco, San Jose, Colonial Manor, Lakewood, Ardsley, Miramar, St. Nicholas, Englewood, and Love Grove. Existing alongside housing developments were businesses, churches, schools, and even theme parks like the beautiful Oriental Gardens, a favorite location for high school photographs.

Churches such as All Saints Episcopal, St. Mark's Lutheran, Southside Baptist, and Southside Methodist on Hendricks Avenue sprang forth. St. Paul's Episcopal in South Arlington had its beginnings (1879) in the Stevens home on Campbell Avenue (Richard land grant) when Harriette Stevens of Rushford, Minnesota, saw the need for Sunday services. Families not only flocked to churches for moral and ethical values but also enjoyed entertainment in plays, covered-dish dinners, and picnics. The cover of this book displays the growth of St. Paul's Episcopal as it met parochial needs from a mission to a full parish in 1957. It was no longer a river church where clergy arrived by boat. The bridge over the Little Pottsburg was built in 1926. The Big Pottsburg River, often called the Arlington River, was connected to Clifton by a wooden bridge in 1927; the last vestiges of this original bridge were removed in the early 1990s, when it was no longer stable as a fishing pier.

In the 1960s, another huge development was the arrival of the interstate system (Interstate 95); it was an even faster method of travel with outreaches into the farther corners of the county, and development soon followed. The early neighborhoods began to observe an alteration as a result of this speedway. Businesses disappeared, houses were razed, and streets were altered forever. The intersection of Atlantic Boulevard and Kings Avenue was once a bustling heart of the area known as "Times Square," and it disappeared into the shadows under the Atlantic Boulevard overpass.

Again, change is coming to the Southside. The Overland Bridge Project, in preliminary stages, will widen Interstate 95 from San Diego Road in the former Philips community to the Fuller Warren Bridge. It will eliminate more pieces of Southside's past. These sacrifices will once again streamline the passage from north to south. New trails, new landmarks, and new developments will soon follow. An unknown wise woman once said, "Change is a part of life. Take a picture and move on."

So turn the page and peruse these photographs. Follow the footprints of those who have gone before. Their stories, memories, and experiences are recorded for your entertainment and perspective throughout the fabric of life.

—Merilyn Chupp Kaufmann, historian, St. Paul's Episcopal Church

One

EARLY DAYS

FERRIES, BRIDGES, AND PIONEERS

This 1918 map of South Jacksonville reveals a large number of buildings, even before the coming of the first automobile bridge, the St. Johns River Bridge (the Acosta), in 1921. Visible near the center is the Gamble Stockton brick company with its clay pit that was later transformed into Lake Marco. Note the community of Philips, a town all but forgotten today except for the local designation of US 1 as "Philips Highway." (Courtesy of the Pennsylvania State Library's Map Library.)

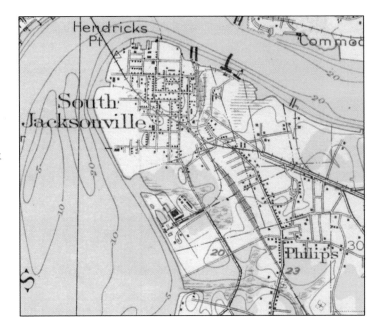

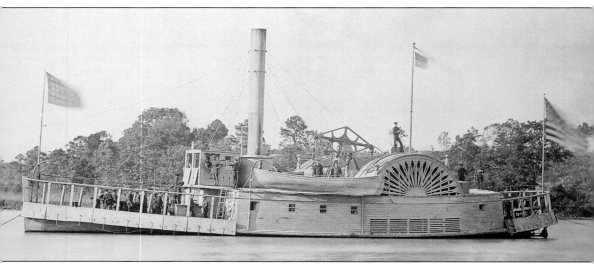

Seen here during the Civil War is the *Commodore Barney*. It was acquired by the Union navy and repurposed from its original use in New York City as the ferryboat *Ethan Allen*. Assigned to the North Atlantic Blockade, *Commodore Barney* participated in such wartime operations as the seizure of Roanoke Island, the Chowan River reconnaissance, the capture of New Bern, North Carolina, and the Pamunkey River expedition. Later, while patrolling on the James River, *Commodore Barney* was hit by a torpedo. Twenty crewmembers were thrown overboard, and two of them drowned. After the war, *Commodore Barney* returned to a quiet life cruising the James and Appomattox Rivers. In 1885, this former gunboat was sold and became one of Jacksonville's ferryboats. Wrecked on September 22, 1901, the remains of *Commodore Barney* now lie somewhere near the Acosta Bridge. (Courtesy of the National Archives.)

This is the Bruce Happ home, located on St. Johns Avenue (today called Prudential Drive). This house, with its beckoning rocking chairs, was located near where the Baptist Hospital complex now stands. The home was once surrounded by pastureland where cattle grazed. The house and pastures are now long gone. The house succumbed to fire many decades ago, as did many wood-frame dwellings of that time. (Courtesy of Cleve Powell.)

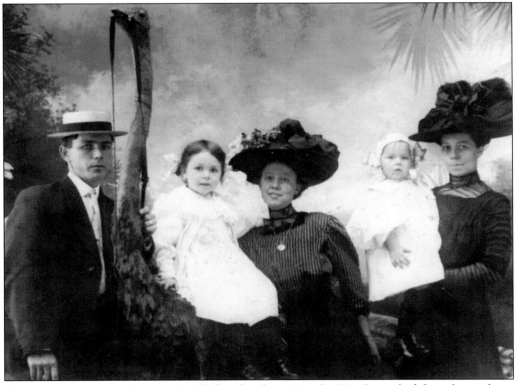

This real-photo postcard shows the Walker family on May 7, 1911. Several of their descendants still live on the Southside. The family members are, from left to right, Ernest Walker, Violet, aunt Jude, Estill, and Minnie Walker. Close examination of the photograph reveals that Ernest Walker has his left arm around the neck of a stuffed ostrich, upon which Violet is seated. (Courtesy of S. Andrews.)

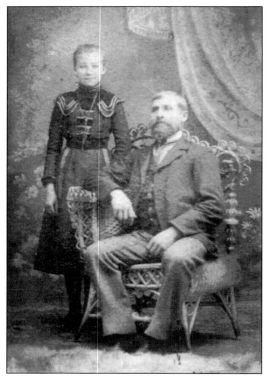

Some of the earliest settlers on Jacksonville's Southside were immigrants. Pictured on the left is Hilda Marie Hokeson standing beside her father, Martin Hokeson. Hilda was born on October 1, 1888, in the small town of Bosta, Sweden. In the late 1800s, when Martin left Sweden seeking a better life in the United States, Hilda came to join him. Originally, they settled in Narytown, near Pittsburgh, Pennsylvania, where Martin found work in the coal mines. It was in Pittsburgh that Hilda met Nels Peterson, and soon, they were married. Following the birth of their first child, Martin Philip ("Phil"), they, along with Hilda's father Martin, moved south. First they settled in Hilliard, Florida, but later they moved to South Jacksonville. The year was 1910. The tintype below shows Martin Hokeson (second row on the right) posing with his coal miner colleagues in West Virginia. (Both, courtesy of the Peterson family.)

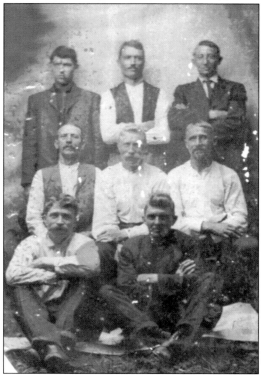

This is the only known photograph of Nels Peterson. The exact date is unknown, but it appears to have been taken during his later years. Nels was born in the northern part of Sweden in the city of Trelleborg on March 6, 1880. There he worked as a stevedore until he saved enough money to book his passage to America. Nels settled first in Pittsburgh, Pennsylvania, and it was there he met and married Hilda Hokeson. Not long afterwards, they moved to Florida. They arrived in South Jacksonville in 1910, and Nels purchased a nine-acre farm on Community Road, off St. Augustine Road. On this property, they farmed and raised a family whose descendants still live on the Southside. On August 22, 1930, Nels died at St. Vincent's Hospital after a long illness involving paralysis. He was only 50 years old. Nels Peterson is buried in Oaklawn Cemetery. (Courtesy of the Peterson family.)

This photograph, probably taken in Sweden, shows a young Hilda Marie Hokeson (right) standing with her arm around an unidentified girl, possibly her sister. Not long after this picture was taken, Hilda left Sweden to visit her father in America. She never returned to live in Sweden, preferring instead to stay in the United States. (Courtesy of the Peterson family.)

This 1880s photograph from Sweden is a mystery. It is believed to show Hilda Hokeson as a toddler, probably being held by her mother. This photograph was lovingly tucked away in a box of mementos by one of Hilda's children. The back of the picture reveals no information that can be used to confirm the identities of the mother and child. (Courtesy of the Peterson family.)

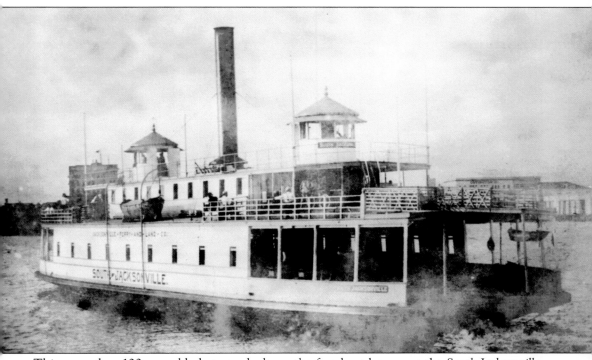

This more-than-100-year-old photograph shows the ferryboat known as the *South Jacksonville*. It was built at the Merrill-Stevens Shipyard in 1913 and put into service on the St. Johns River transporting automobiles and people from downtown Jacksonville to South Jacksonville. When the first automobile bridge across the St. Johns River was built in 1921, the ferry was sold and began a new life with the new name *Mount Holly*. Under this title, it served passengers on the Delaware River; later rechristened *Governor Emerson C. Harrington II*, it ran on the East River between Long Island City and East Thirty-fourth Street in Manhattan. In 1945, its coal-fired steam boilers were replaced with a pair of six-cylinder diesel engines. In 1954, it was sold again, this time to the Lake Champlain Transportation Company. Today, those wishing to ride the waves on a part of Jacksonville history can do so. Under the new name *Adirondack*, it continues to run today between Burlington, Vermont, and Port Kent, New York. It is the oldest double-ended ferry still in service in North America. (Courtesy of the State of Florida Photographic Archives.)

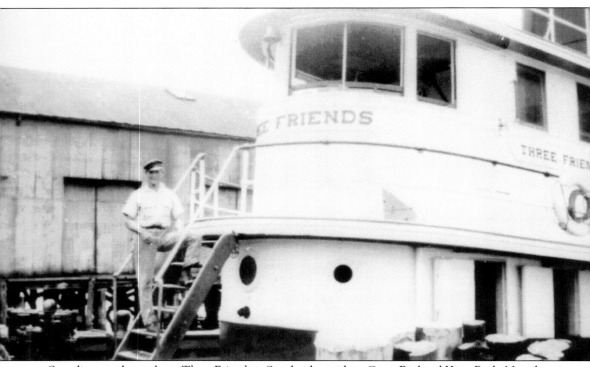

Standing on the tugboat *Three Friends* is Southside resident Capt. Richard King Peck. Napoleon Bonaparte Broward, his brother Montcalm Broward, and George DeCottes built this historic vessel in Jacksonville in 1895. The following year, with Napoleon Broward at the helm, the *Three Friends* began making runs to Cuba, loaded with cargo listed as "groceries." In reality, the tug was stocked with ammunition and arms intended to supply the rebels in the Cuban revolution. The runs to Cuba were so daring that the United States sent the battleship *Maine* to Havana to protect the Americans from the Spanish. Two months later, the *Maine* exploded, 266 lives were lost, and the United States declared war against Spain. After the war, the *Three Friends* returned to work as a harbor tug on the St. Johns River. After World War II, efforts to make it a museum ship failed, and it was allowed to sink to the bottom of the river. Its steam engine was salvaged years later and is now in the possession of the Jacksonville Maritime Museum Society. (Courtesy of "Dede" Dowling Rehkopf.)

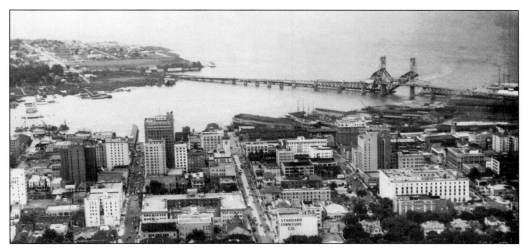

This 1940s aerial view shows the St. Johns River Bridge (the Acosta) and the railroad bridge appearing to blend together in the distance. Close examination of the left side of the photograph reveals early construction of the foundation piers of what would become the Alsop Bridge. Upon completion, this bridge was commonly referred to as the "new bridge." Today, most Jacksonville residents call it the Main Street Bridge, or simply "the blue bridge."

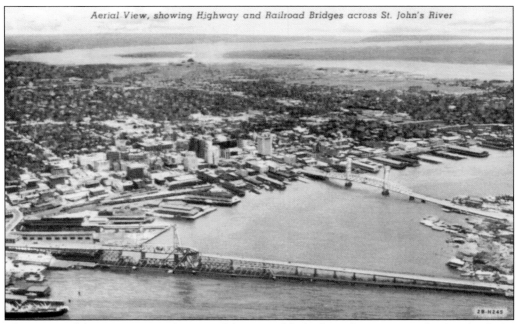

This postcard features an easterly view of the critical links from downtown to the Southside. In the foreground is the railroad bridge, and directly behind it is the Acosta Bridge. Spanning the narrowest point of the river is the John T. Alsop Bridge, more commonly known as the Main Street Bridge. This postcard also reveals the unique S-curve shape of the St. Johns River.

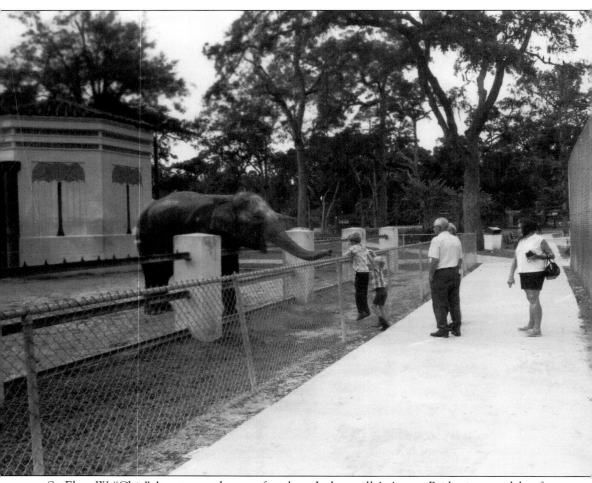

St. Elmo W. "Chic" Acosta was the man for whom Jacksonville's Acosta Bridge is named, but few people remember that he was instrumental in acquiring the first elephant for the Jacksonville zoo. A 1925 newspaper article called his effort to get this elephant a "monument to persistency." When the city commission would not budge, Acosta turned to public subscription, collecting donations, which included pennies and nickels from the children of Jacksonville. The elephant was acquired in 1926 and escorted to her new home by many of those same boys and girls who donated money, riding bicycles. This 1970s photograph shows an elephant (not Miss Chic, who died on November 10, 1963) entertaining visitors at the Jacksonville Zoo. The building behind her was built in 1935 and designed by architect Roy Benjamin, the same man who designed the San Marco Theater. The octagonal elephant house had a large door and two bands of glass bricks near the tile roof that allowed sunlight to flood the interior. It was ultimately torn down and replaced. (Courtesy of the State of Florida Photographic Archives.)

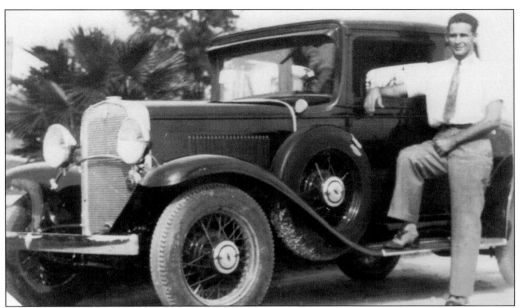

On July 1, 1921, the first automobile bridge, named the St. Johns River Bridge (later called the Acosta), opened to great fanfare. Within three days, the bridge was used by almost 5,000 automobiles. The bridge connected to Miami Road (now Prudential Drive) with a continuation to San Marco Boulevard. Seen here is Philip Peterson, posing with his foot on the running board of his Chevrolet. (Courtesy of the Peterson family.)

This picture depicts a calm day on the St. Johns River, with the downtown skyline and bridges visible in the distance. The scene was photographed from the Riverside area in the 1940s. Framed by a row of cabbage palms are the railroad bridge (in the raised position) and the Acosta Bridge, just barely visible behind it.

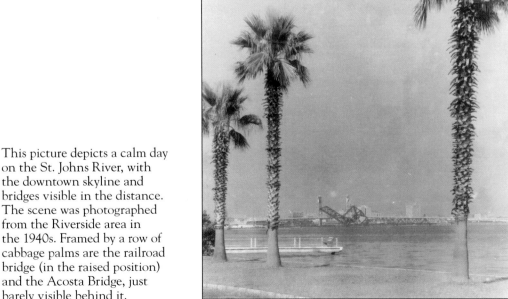

South Jacksonville, with a population of 600, was incorporated in 1907. It encompassed 3.24 square miles and called itself "the City of Opportunity." When it was absorbed by Jacksonville in 1932, the population had swelled to 5,658. Little remains from that time, but the original city hall still stands on the northwest corner of Hendricks Avenue and Cedar Street. This intersection was at one time the hub of that small city called South Jacksonville.

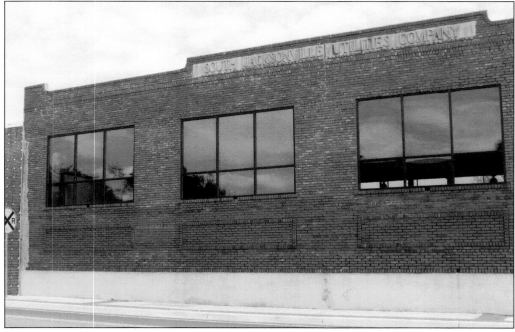

The photograph above shows the former South Jacksonville Utilities Company. Located diagonally across Hendricks Avenue from the city hall, on the northeast corner, the building still exists. Its windows have been replaced, and the structure is vacant, but the sign across the top provides a poignant reminder of its former use, providing the lifeblood of a small but growing community. A 1949 Sanborn map lists a later tenant of the building as Consumers Ice Company.

RE-ELECT
A. D. MARJENHOFF
FOR
COUNCILMAN
4TH WARD

YOUR VOTE WILL BE APPRECIATED

CITY ELECTION JUNE 3, 1930

20

Alex D. Marjenhoff served on the South Jacksonville City Council from 1928 to 1932 and was president of the city council when South Jacksonville was annexed into the city of Jacksonville in 1932. This photograph shows one of Marjenhoff's business cards used during his reelection campaign in 1930. It politely states, "Your vote will be appreciated." (Courtesy of Fred Marjenhoff.)

This 1905 photograph shows Alex Marjenhoff as a boy. He is standing between Fritz Marjenhoff and Johannes Marjenhoff. The adults are attired in full uniform, complete with plumed headgear. Note the sword being held by Johannes Marjenhoff. The exact occasion for this photograph is unknown. (Courtesy of Fred Marjenhoff.)

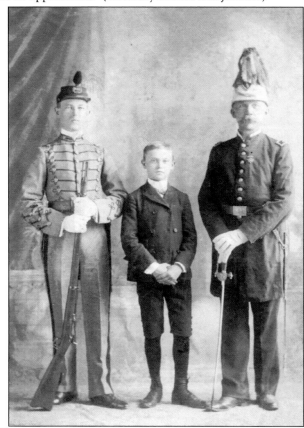

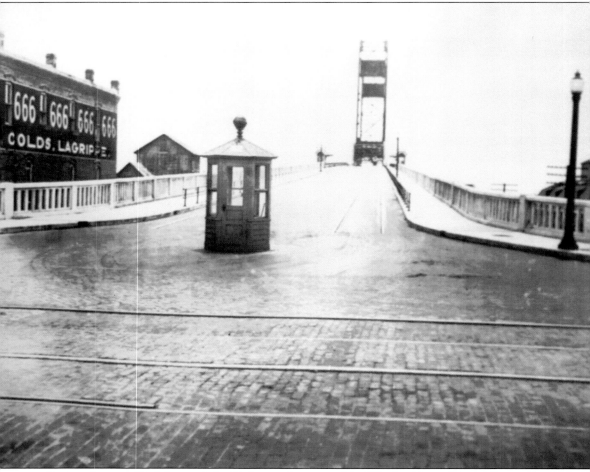

During the era of Prohibition, John Hysler was known as "the Whiskey King of Duval County" and was even rumored to be an associate of Al Capone. Still, not everyone regarded him unfavorably. Hysler met his end on the Acosta Bridge one night in 1928 while making a whiskey run from Mineral City (Ponte Vedra). After getting a tip about that run, Prohibition agent Hope King hid himself at the bridge's tollbooth while agent Tim Easton waited at the other end of the bridge. When Hysler appeared in his Chrysler roadster, he stopped at the tollbooth. That is when King appeared. No one knows who shot first, but both men fired their guns until they were empty. Hysler was shot five times and taken to St. Vincent's Hospital. He died later that night. His funeral was attended by almost 1,500 citizens, with local politicians, lawyers, and police officers serving as pallbearers. (Courtesy of the State of Florida Photographic Archives.)

The little girl standing next to the Belmont Avenue signpost is Muchia Ann Brown, born on November 26, 1944. Her parents were Thomas "Brownie" Brown and Avanell Gibbs Brown. Brownie served in the Navy as a chief torpedo man's mate during World War II. He was aboard the USS *Orestes* in the Leyte Gulf when a Japanese "Val" bomber crashed amidships, killing him and 44 other crew members. Muchia Ann was only a month and four days old when he died. The photograph below was taken in 1945 and shows Muchia Ann standing on Cedar Street. The building in the background housed the cafeteria for Southside Grammar School No. 7. The brick Southside Grammar School building is now the Lofts San Marco, a condominium complex. It was added to the National Register of Historic Places in 2004. (Both, courtesy of Thomas Reeves.)

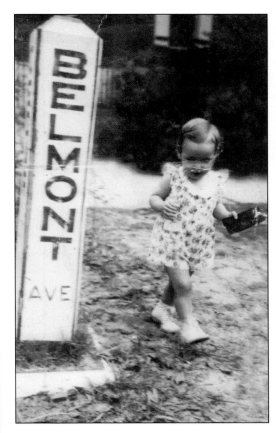

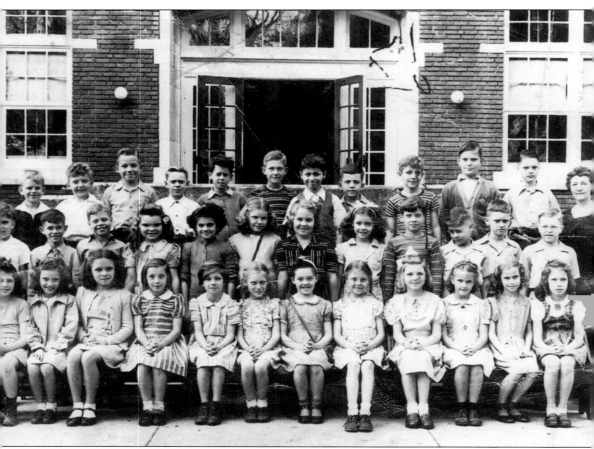

This is a 1945 photograph of Mrs. Gerard's third-grade class at the Southside Grammar School No. 7. The principal at the time was Mr. Bricky (not pictured), whose office was left of the front door. He later transferred to North Shore Elementary School and was replaced by Mr. Charles. The students are, from left to right, (first row) Beverly May, Elverta Hucks, Melba Jacobs, Shirley Meadows, unidentified, Virginia Bryant, Jeanette Surles, Justine Austill, unidentified, Florence Ann Rowe, Joanne Shepard, and Patsy Daniels; (second row) Ricky Harrow, Clement Frazier, Sammy Austill (twin brother of Justine Austill in front row), Emily Casey, Barbara Morrison, unidentified, Judy Morris, June Yancey, Pat Robinson, Charles Haimowitz, Richard Murphy, unidentified, and Mrs. Gerard; (third row) Clinton Parker, unidentified, Warren Fair, Raymond Gamble, Milton Futch, Tommy Reeves, Marvin Kramer, Stanley Janes, unidentified, Napoleon ?, and Richard Futch. During this historic year, World War II in Europe ended and the Japanese surrendered following the atomic bombing of Hiroshima and Nagasaki. Most of the students pictured here became the 1955 graduating class at Landon High School. (Courtesy of Thomas Reeves.)

Two unidentified newlyweds appear on the steps of All Saints Episcopal Church. Today, All Saints Episcopal Church is located on Hendricks Avenue near the Miramar Shopping Center. This photograph shows the original building, which stood on the corner of Hendricks Avenue and Nira Street during the time when the area was known as South Jacksonville. Notice the novelty siding on the building. (Courtesy of the State of Florida Photographic Archives.)

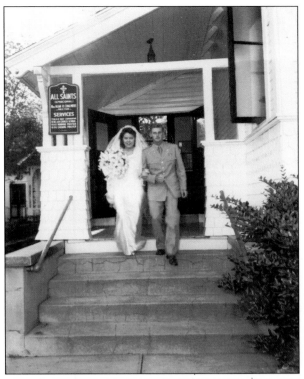

Another early church on the Southside was the First Baptist Church of South Jacksonville. The building pictured above was located on the corner of Home and Kipp Streets. Today, that area is only a few blocks from the popular Tidbits restaurant. The church members in this early 1900s photograph are unidentified. (Courtesy of Southside Baptist Church.)

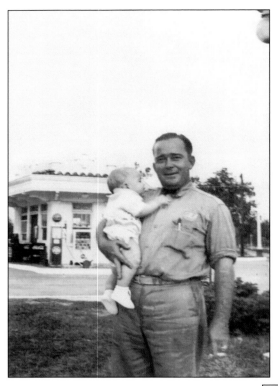

Phineas Miller Rousseau is seen in the left photograph holding his infant son Miller. This picture was taken during the early days of the San Marco development. Visible behind them is the distinctive Gulf gas station located in the center of San Marco Square. Today, this spot is occupied by Balis Park and its beautiful gazebo. The picture below shows Phineas Miller Rousseau in his uniform. Over the years, Rousseau was the manager of several Gulf stations in the area, including the one in San Marco Square. The Gulf gasoline company promoted the concept of selling gasoline in containers and from pumps marked with its distinctive orange disc logo to assure customers that they were getting a quality product. (Both, courtesy of Miller Rousseau.)

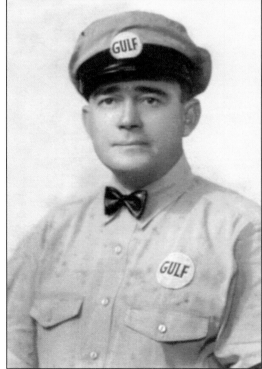

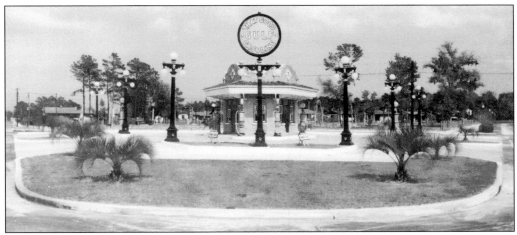

This 1928 photograph shows the Gulf station in San Marco Square. The small signs at ground level between the lampposts read, "Coming soon." This picture was apparently taken right before the service station opened for business in the brand new San Marco Square development. The large round sign proclaims, "That good gasoline Gulf." (Courtesy of Southside Baptist Church.)

This is a 1940s-era aerial photograph of San Marco Square. The original, iconic Gulf station building has been replaced with a larger, more modern building visible at the top center of the picture. The centerpiece San Marco fountain can be seen just above the double line of parked automobiles. (Courtesy of Southside Baptist Church.)

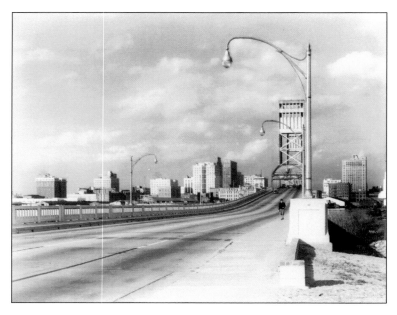

Beneath arched streetlights, a solitary figure walks across the John T. Alsop Bridge (Main Street Bridge) soon after the bridge was completed. The picture was taken some time in the 1940s. This vertical lift drawbridge opened with great fanfare in July 1941. It was named for Mayor John T. Alsop, but today, it is more commonly known as the Main Street Bridge.

This is an aerial photograph of the Main Street Bridge from approximately the same time period. It reveals the many industrial buildings that made up a large portion of the Southbank. Most of these structures were demolished to prepare for the expressway system in the 1960s. Prior to the building of the structures seen in this photograph, part of this area housed Dixieland Park and the Ostrich and Alligator Farm.

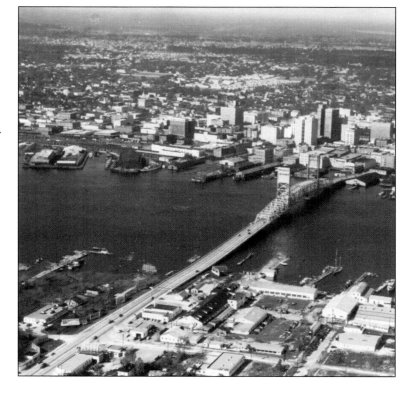

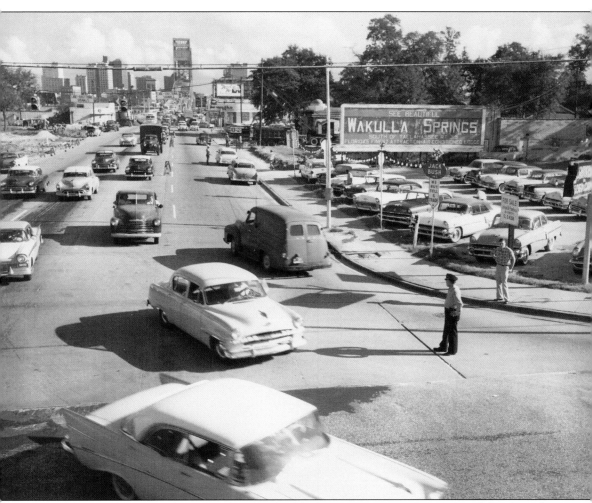

A true snapshot in time is this 1950s photograph of the busy intersection of Miami Road (Prudential Drive) and Main Street. This crossroads was so heavily used that a policeman was required to direct traffic and keep it flowing smoothly. Only a few years after this photograph was taken, the landscape changed forever. Part of the expressway system for Interstate 95 was built here, replacing almost everything seen in the picture. Notice that the John T. Alsop Bridge (Main Street Bridge) is clearly visible in the distance. One Landon graduate, Richard Rousseau, remembers a young man who worked at the auto dealership seen on the right. This man was memorable for his ability to do multiple chin-ups using only one arm. The billboard is advertising Wakulla Springs, a favorite tourist destination located in the panhandle of Florida, near Tallahassee. It featured glass-bottomed boats. (Courtesy of the State of Florida Photographic Archives.)

This house still exists on the east side of San Marco Place behind the Southside Baptist Church. It was built in 1934. At one time, mules owned by the Ploof Company grazed in this pastureland. Not visible in this photograph is a beautiful and massive live oak tree whose heavy limbs brush the ground. (Courtesy of the Peterson family.)

This 1950s-era photograph was taken on San Marco Place in the front yard of the house in the previous picture. Standing in the yard are, from left to right, John Peterson, Ken Peterson, Becky Peterson, Howard Vollers, and Barbara Vollers. San Marco Place is a short curved street that begins on Hendricks Avenue and exits on Atlantic Boulevard beside the San Marco Fire Station. (Courtesy of the Peterson family.)

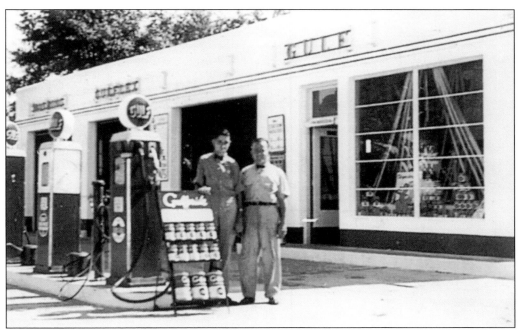

The service station building seen here still stands but is now used for an entirely different purpose. Pictured above are Alvin Brooks (left) and station manager Phineas Miller Rousseau standing in front of the new, much larger Gulf station that was built years after the iconic one located in the center of San Marco Square. This building on the northeast corner of Hendricks and Landon Avenues housed a service station for several decades. It was not until the 1990s that the gas pumps were removed, and the station building began a new life as a Quizno's restaurant. Today, the structure houses a Jimmy John's sandwich shop, seen below. (Above, courtesy of Richard Rousseau.)

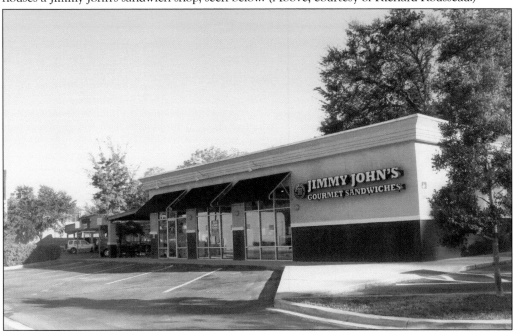

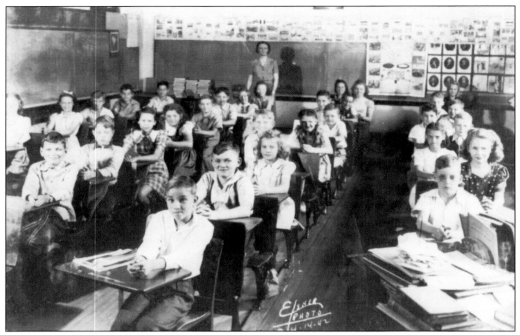

This is a photograph of the interior of Southside Grammar School No. 7 in 1942. The teacher and students are unidentified. During this year, US gas rationing went into effect at three gallons per week, the Manhattan Project began, and the minimum draft age was lowered from 21 to 18. Many of these students went on to attend Landon High School. (Courtesy of the Landon Alumni Association.)

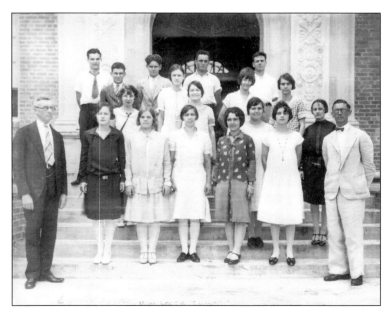

Landon Junior and Senior High School was built in 1927 on the east side of Thacker Avenue. Until it was completed, students who lived in South Jacksonville had to take a ferry across the St. Johns River to attend Duval High School. This is a photograph of the first graduating class at Landon High School in 1928. The principal, R.C. Marshall, is standing on the left. (Courtesy of Cleve Powell.)

This group from Landon High School is standing on the southeast corner of Landon and Hendricks Avenues. The building on the left is the Landon and Varn grocery store. At this time, milk was 25¢, according to an advertisement in the window. The building still stands, minus the awning, and has recently been refurbished. (Courtesy of the Landon Alumni Association.)

Posing at the intersection of Marco Place and Broadmoor Lane is an unidentified Landon cheerleader with her megaphone. Behind her is the park, originally called the Southside Athletic Field. Landon students used it as a practice field for many years. Later, the name was changed to FEC Park in honor of the Florida East Coast Railroad. Around 2011, the park was renamed Alexandria Oaks Park, and walking paths and new landscaping were added. (Courtesy of the Landon Alumni Association.)

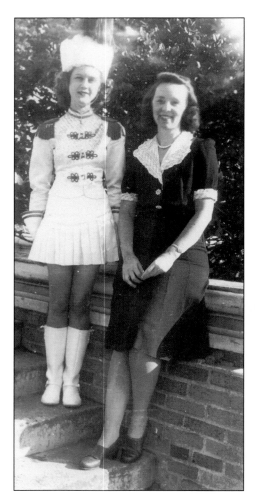

The left photograph was taken during the 1942–1943 school year and shows Majel Rees wearing her Landon majorette's uniform. Next to her is Kathleen Turner, the teacher who coached the Lionettes marching team to national fame. Turner was a teacher and coach at Landon over several decades. She is remembered as a tough taskmaster by many of her former students but also as a caring instructor who took students in need under her wing. Majel Rees, daughter of Mr. and Mrs. Jack Rees, was a majorette almost every year of her high school career. A newspaper article of the day quotes Kathleen Turner as saying, "Majel is doing wonderfully well." (Both, courtesy of the Landon Alumni Association.)

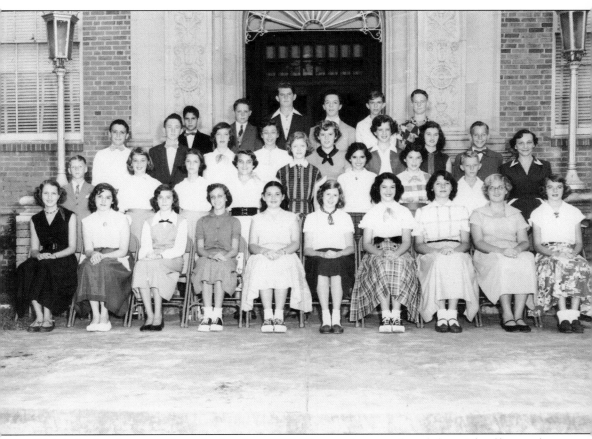

This is the Landon seventh-grade class from 1952. The members are, from left to right, (first row) Gail Burke, three unidentified, Frances Daniels, Alma Griffin, Irma Warner, Marilyn Berry, Carolyn Monroe, and Martha Maguire; (second row) Richard Titus, two unidentified, Peggy Casey, Patricia Land, Marcia Falis, Mary Lou Wrench, Charles Beasley, and teacher Grace Goldberg; (third row) Vernon Branch, two unidentified, Lillian Sutton, unidentified, Janet Wells, Carolyn Sistrunk, and Ken Peterson; (fourth row) Robert Soud, Thomas Ford, John Cowart, Julian Bleacher, Hugh Simmons, and Donald Petty. In 1952, the *Today* show premiered on NBC; the Winter Olympics were held in Oslo, Norway; the first successful surgical separation of conjoined twins was achieved in Ohio; and Winston Churchill announced that the United Kingdom had an atomic bomb. For many years, a yellow-and-black fallout shelter sign was prominently displayed outside Landon's main entrance. (Courtesy of the Peterson family.)

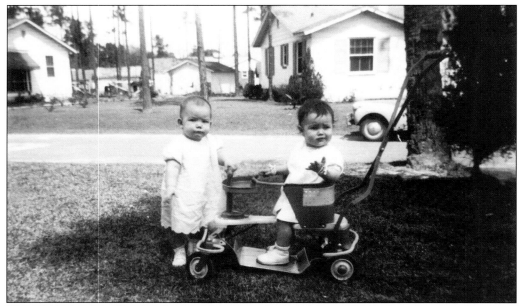

This 1942 photograph was taken on Southampton Road near Old Hickory Road in the South Shores area. Clyde Montgomery is on the left, and Sharon Andrews is in the stroller. During this period, it was not uncommon for male toddlers to wear "dresses." As an adult, Clyde Montgomery worked for the television station Channel 12 and the Jacksonville Electric Authority. (Courtesy of the Andrews family.)

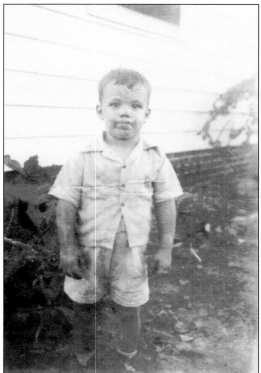

This is a photograph of Clyde "Billy" Andrews. He is standing outside his Southampton Road home, looking like many little boys with his well-rumpled suit of play clothes and dirt-caked face. He must have been having a wonderful time! Clyde grew up to become a respected endodontist who now lives in Savannah, Georgia. (Courtesy of the Andrews family.)

These Landon High School majorettes with their plumed hats and double-breasted uniforms appear to be doing a promotional event at a car dealership. The exact location is unknown, but the year 1946 can be seen on the banner that is visible on the upper-right side of the photograph. The participants are unidentified. (Courtesy of the Landon Alumni Association.)

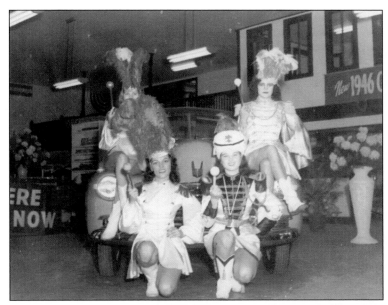

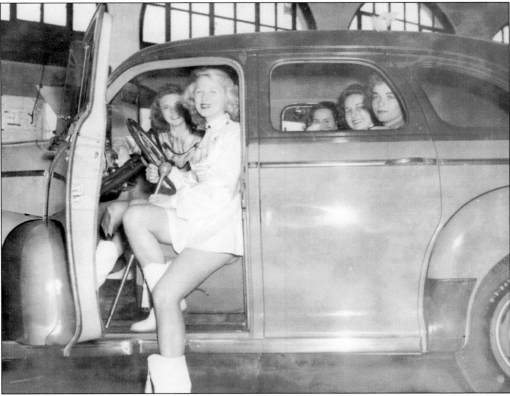

The smiling young Landon High School majorette holding her baton is seen here posing with her friends in a shiny new automobile. This photograph may have been taken at the same event and in the same automobile dealership as the previous picture. The young ladies are all unidentified. (Courtesy of the Landon Alumni Association.)

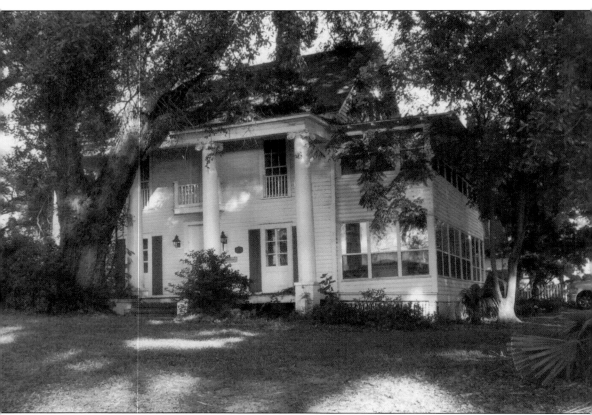

This beautiful historic home is located in Clifton on part of the original Richard land grant. Known as the Sammis home, it was built in 1858. On July 10, 1979, it was added to the National Register of Historic Places. John Sammis was the son-in-law of Anna Jai Kingsley. Anna Kingsley was married to plantation owner Zephaniah Kingsley, who had purchased her as a slave in 1806. They had four children together. He freed her in 1811, and she took over much of the responsibility of operating her husband's extensive holdings. She also owned over 350 acres of her own property. After her husband's death, she settled in the Clifton area. She died in 1870 at age 77. Not far from the Sammis home is the Clifton Cemetery, which contains one of the oldest tombstones in Duval County. It is the grave of six-year-old Julia C. Baxter, granddaughter of Zephaniah Kingsley. It is dated 1841. (Courtesy of Merilyn Chupp Kaufmann.)

Two

Atlantic Boulevard
The Original Beach Road

On July 28, 1910, the formal opening of Atlantic Boulevard was held. The road ran from South Jacksonville to Mayport Road. Atlantic Boulevard was a brick road for many years and is remembered as such by longtime residents. The bottom of this 1955 zoning map shows the curve of Atlantic Boulevard near its intersection with Kings Avenue, an area known locally as Times Square. (Courtesy of the City of Jacksonville.)

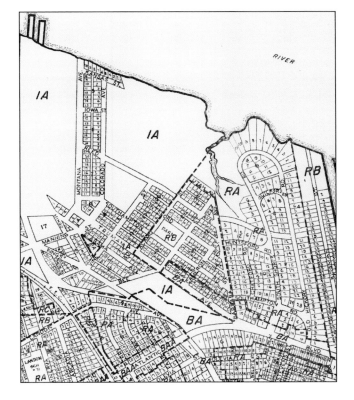

E.F. Gilbert is known as the "Father of Atlantic Boulevard," and Atlantic Boulevard is considered the forerunner of all modern road construction in Florida. It began when Gilbert bought land in Neptune Beach, although there was no easy way to get there. Undaunted, Gilbert worked for six years and finally convinced the Duval County Commission to begin cutting a road from South Jacksonville to the beach. But when the road was half finished, a new county commission halted the project. That is when E.F. Gilbert's son Fred enlisted the aid of W.J. Morgan, a New York promoter. Morgan began encouraging the support of automobile owners and dealers by sponsoring races at the beach. To encourage completion of the road, "Motoring" Morgan, Fred Gilbert, C.H. Mann, and Claude Nolan drove the entire Duval County Commission through the wilderness using a couple of Cadillacs. In July 1910, Atlantic Boulevard was finished. E.F. Gilbert died in 1907 without ever seeing the completion of his road. The 1940s-era photograph above shows Atlantic Boulevard near its intersection with White Avenue. (Courtesy of the State of Florida Photographic Archives.)

Hiding beneath layers of asphalt on many Southside roads is a brick street like this one. This 1947 scene depicts Prudential Drive, looking east, near its intersection with Main Street. At the time, it was called Miami Road. The two-story building visible on the right is the Hotel Embassy. The hotel is long gone now, along with virtually all the other structures in this picture. (Courtesy of the State of Florida Photographic Archives.)

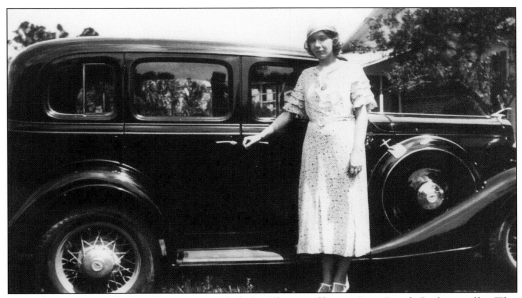

On July 11, 1910, the local paper recorded the "first traffic jam" in South Jacksonville. The headline read, "Autoists spending day at the beach all made rush for the city at the same time!" The ferry crossing from South Jacksonville to downtown had "upwards of 50 cars" waiting at one period. This photograph features Edith Peterson posing beside her Paige 8 automobile. (Courtesy of the Peterson family.)

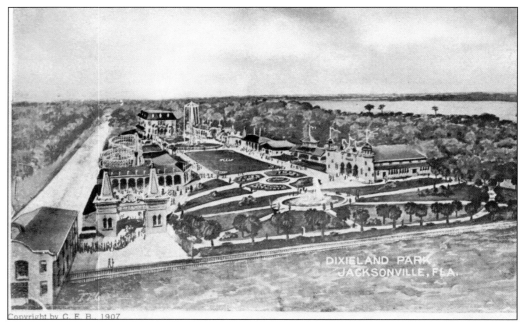

Copyright by C. E. B., 1907

Located where the Main Street Bridge enters the south side was the glorious but short-lived attraction known as Dixieland Park. The rare postcard view above shows the layout of the park in 1907, the year it opened. The park was plagued from the beginning by bad luck and bad weather, including a hailstorm that occurred only a month after the park opened. Newspaper accounts of the day describe hailstones as large as "hen's eggs." The reverse side of this card carries the following inscription, possibly indicating other severe weather: "The building I [illegible] is the theatre and where I was in during the cyclone." The postcard carried no address and was never mailed. The real-photo postcard on the left shows the Florida Ostrich Farm in later years. Behind the determined rider, a remnant of Dixieland Park is visible, a weathered, dome-roofed bandstand.

The Florida Ostrich Farm
JACKSONVILLE, FLA.
"The Largest Ostrich Farm In The East"

The Alligator Farm, located near the foot of today's Main Street Bridge, was popular with locals as well as tourists. This 1932 photograph shows, from left to right, Mr. Johnson, Mildred Shriver, Edith Peterson, and Mr. Wade posing with the alligators. Visitors were not usually allowed inside the alligator pit to be photographed, but apparently, an exception was made on this day. (Courtesy of the Peterson family.)

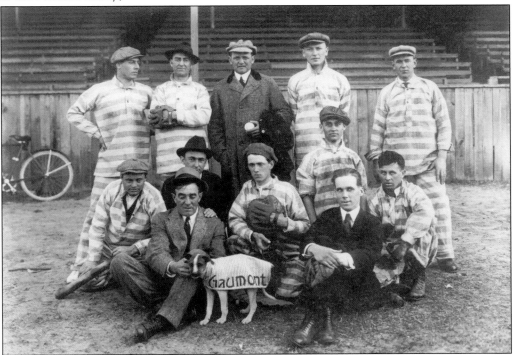

This 1913 photograph was taken at the baseball stadium located near Dixieland Park. Movie studios, such as Gaumont, rented space at Dixieland for several years after the original park had ceased to exist. The Gaumont actors seen here are, from left to right, (standing), Guy M. Carter, unidentified, Richard Garrick, and two unidentified; (kneeling), unidentified, Sidney J. Vaughn, and three unidentified; (sitting) two unidentified. (Courtesy of the State of Florida Photographic Archives.)

These real-photo postcards feature a background that may be related to the Jacksonville Alligator Farm. In the left picture, Ernest A. Walker is seen striking a pose with his elbow resting on a stuffed alligator, a popular prop at the time. In the photograph below, Walker appears again but this time with his wife, Minnie Walker, behind him and grandma Phares beside her. Walker is holding baby Violet. Although the picture was obviously taken in the same location—the potted plant is identical—the alligator has been removed. Perhaps the women did not wish to be photographed with such a creature. (Both, courtesy of S. Andrews.)

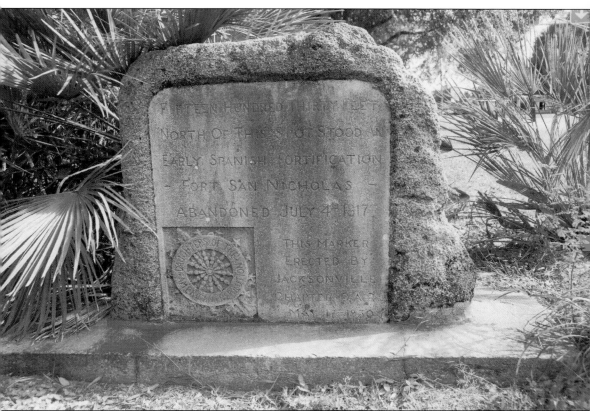

Fort St. (San) Nicholas was one of several fortifications built by the Spanish along the St. Johns River. It was built by Pedro Menendez about 1566 and ringed by a large moat 100 feet square. Behind the moat was a settlement of about four acres, consisting of offices, quarters, stables, and barracks. Fort St. (San) Nicholas was abandoned on July 4, 1817. In 1818, Francis Hudnall purchased the land on which the fort stood. He built his house on the eastern side of the moat and used timbers from the fort for his farm. He raised several crops on the property, including corn, oranges, and sweet potatoes. Over the years, he reported finding many Spanish coins. He later sold this land to Merrill-Stevens Shipbuilding Company. The monument seen in this photograph sits in the median of Atlantic Boulevard near its intersection with White Avenue. Placed there by the Daughters of the American Revolution in 1930, it is almost completely hidden by foliage today and is almost inaccessible because the heavily trafficked roadway surrounds it. (Courtesy of Junius.)

F.W. Bruce is seen sitting in an office at the Merrill-Stevens Shipyard. Bruce was the supervisor of construction of the Merrill-Stevens Shipyard, a position he held until shipbuilding for World War I began. In 1924, he wrote an account of the 1917 construction of the shipyard that includes references to artifacts uncovered from the time of Fort San Nicholas. Bruce described what was found as follows: "The ends of continuous timber palisades were unearthed with the entire tops missing due to fire, decay or other reasons. A well was found with no visible evidence on the surface made of bricks of ancient make and blocks of coquina. Many cannon balls of a caliber of ancient times, an axe, buckles, harness, etc." He also stated that due to the urgency of war, "time could not be devoted to close examination of the relics." (Courtesy of Cleve Powell.)

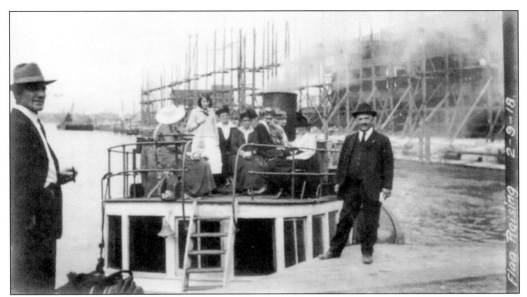

This photograph depicts the occasion of a flag raising at the Merrill-Stevens Shipyard on February 9, 1918. Standing on the dock on the left is F.W. Bruce, and the gentleman on the right is unidentified. The passengers on the boat are also unidentified. Today, the shipyard site is occupied by Bishop Kenny High School. (Courtesy of Cleve Powell.)

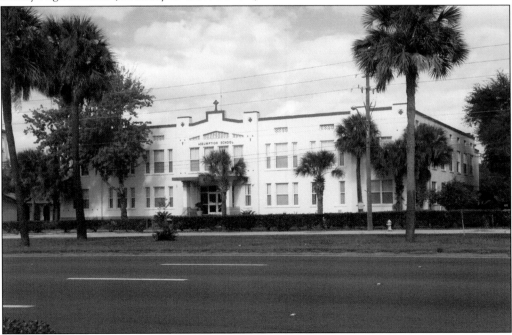

The former administration building for the Merrill-Stevens Shipyard is located just steps away from busy Atlantic Boulevard. It was designed by Henry J. Klutho and built by contractor W.P. Richardson. This structure was Klutho's last Prairie-style building. After the shipyard ceased operation, during the years 1939 to 1942, it was home to the US Works Project Administration Sewing Project. In 1949, it became Assumption School and Bishop Kenny High School. (Courtesy of Junius.)

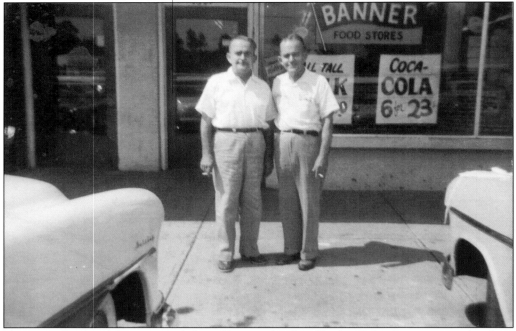

Phineas Miller (P.M.) Rousseau, at left, and his twin brother Charles Walter Rousseau stand in front of the Banner Food Store, located at the intersection of Kings Avenue and Atlantic Boulevard. This area was known locally as Times Square. Almost all the buildings were demolished during the 1960s and 1970s to make way for the construction and expansion of Interstate 95. The land that once housed the businesses that made up the northeastern and southeastern blocks is now located in the shadows beneath the Interstate 95 overpass on Atlantic Boulevard. The map below depicts the businesses that were located at the Times Square intersection of Atlantic Boulevard and Kings Avenue. Note the original location of Bono's Barbeque, a small kiosk that featured outdoor dining with seven stools for the convenience of the restaurant's patrons. (Above, courtesy of Richard Rousseau; below, courtesy of Thomas Reeves.)

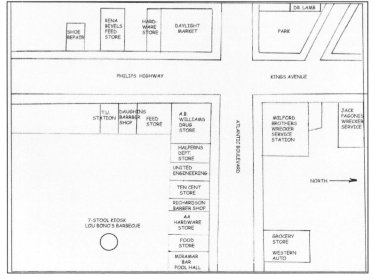

This is a page taken from a brochure called "The Skater." This small publication was probably related to the popular Skateland, located on Kings Avenue. Notice the reference to Times Square in the beauty shop advertisement on the top right, along with ads for several nearby businesses. The photograph below shows the building that housed Skateland. It still exists on Kings Road. Today, it is home to PRI Productions. Prior to that, it housed Brandon's, a camera and photography supply business. When the current owner tore down a wall during renovations, he discovered a cache of memorabilia from the days of Skateland. He recovered old wallets, identification cards, skates, and rings. Perhaps some of these items were tucked away with the "1 memory in writing" mentioned in the lost notice seen here. (Right, courtesy of the Landon Alumni Association.)

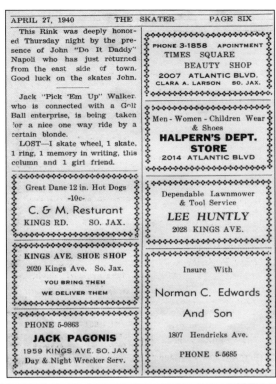

APRIL 27, 1940 THE SKATER PAGE SIX

This Rink was deeply honored Thursday night by the presence of John "Do It Daddy" Napoli who has just returned from the east side of town. Good luck on the skates John.

Jack "Pick 'Em Up" Walker, who is connected with a Golf Ball enterprise, is being taken for a nice one way ride by a certain blonde.

LOST—1 skate wheel, 1 skate, 1 ring, 1 memory in writing, this column and 1 girl friend.

PHONE 3-1858 APOINTMENT
TIMES SQUARE
BEAUTY SHOP
2007 ATLANTIC BLVD.
CLARA A. LARSON SO. JAX.

Men - Women - Children Wear
& Shoes
HALPERN'S DEPT.
STORE
2014 ATLANTIC BLVD

Great Dane 12 in. Hot Dogs
-10c-
C. & M. Resturant
KINGS RD. SO. JAX.

Dependable Lawnmower
& Tool Service
LEE HUNTLY
2028 KINGS AVE.

KINGS AVE. SHOE SHOP
2020 Kings Ave. So. Jax.
YOU BRING THEM
WE DELIVER THEM

Insure With
Norman C. Edwards
And Son
1807 Hendricks Ave.
PHONE 5-5685

PHONE 5-9863
JACK PAGONIS
1959 KINGS AVE. SO. JAX
Day & Night Wrecker Serv.

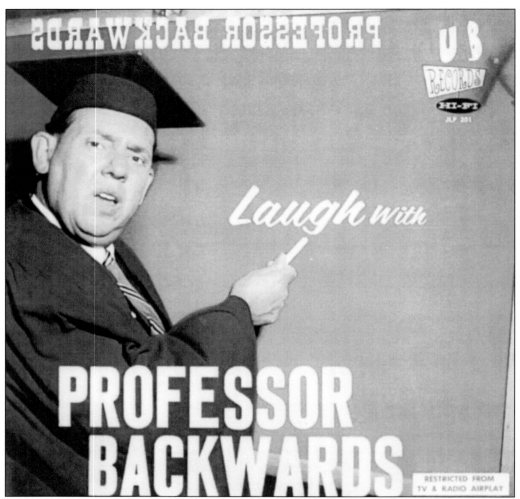

This old LP cover depicts famous Southside resident Professor Backwards. He was a comedian who appeared on television from the 1950s until the 1970s, performing on national programs like *The Ed Sullivan Show*, *The Mike Douglas Show*, and *The Tonight Show*. He also appeared on local Jacksonville programs. In his early days, he worked for the *Florida Times-Union* as a typesetter, and thus his skill at writing upside down and/or backwards was developed—skills that later formed the basis of his comedy act. Professor Backwards could spell and pronounce words backwards, as well as read an inverted blackboard. His real name was James Edmondson, and he lived on Old Hickory Road. He is well remembered by one of his neighbors, Richard Rousseau, a young Landon High School student. He recalls helping Edmondson with his act by carrying his blackboard for him. Sadly, Edmondson was murdered on January 29, 1976, in Atlanta. The culprits were arrested and convicted on charges of murder and armed robbery.

Marjenhoff Park, located in the Reeds subdivision, was created out of an area that was mostly swampland. The land for the park had been donated by Lilla M. White in 1923, with the stipulation that it be used for a public park. It was not until 1929 that the park project began, spearheaded by Alex Marjenhoff. Using salvaged materials, the marsh was filled in, and a small lake with an island in the middle was created. The South Jacksonville Parks Department established a grassy lawn, and local residents contributed landscaping for the park by donating trees and plants. In recognition of Marjenhoff's efforts, the city named the park in his honor in October 1931. It was dedicated in December 1931. In the photograph below, Alex Marjenhoff is posing in front of his home, located across from the park on the corner of Huntsford Road and Bee Street. (Both, courtesy of Fred Marjenhoff.)

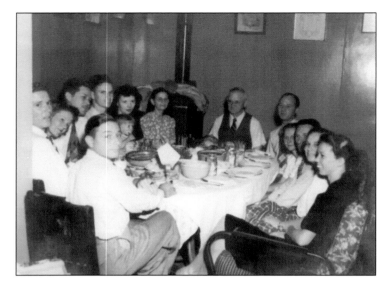

The extended Marjenhoff family is seen here enjoying Christmas dinner in 1945. They were photographed in the dining room of the Marjenhoff home on Huntsford Road, shown on the previous page. At the far head of the table is Alex D. Marjenhoff, with his wife, Marie, seated to his right. The napkin standing up in the foreground reads "Charlie." (Courtesy of Fred Marjenhoff.)

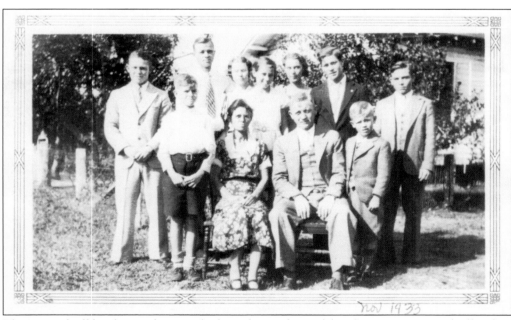

The Marjenhoff family was photographed standing in front of their home near Marjenhoff Park in November 1933, possibly a Thanksgiving celebration. They are, from left to right, (first row) Richard, Marie Marjenhoff, Alex Marjenhoff, and Fred Marjenhoff; (second row) Frank, Alex, Myrtle, Estelle, Margaret, Arnold, and Marion. Fred Marjenhoff grew up to become a 35-year employee of the Jacksonville Department of Parks and Recreation. (Courtesy of Fred Marjenhoff.)

This is a photograph of three unidentified gentlemen posing with their Indian motorcycles. Indian motorcycles were produced from 1901 to 1953 by a company in Springfield, Massachusetts. During the 1910s, it was the largest manufacturer of motorcycles in the world. Note that the men are wearing suits and ties. (Courtesy of St. Paul's Episcopal Church.)

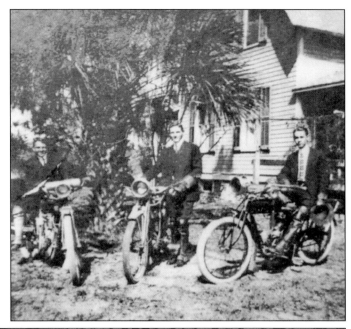

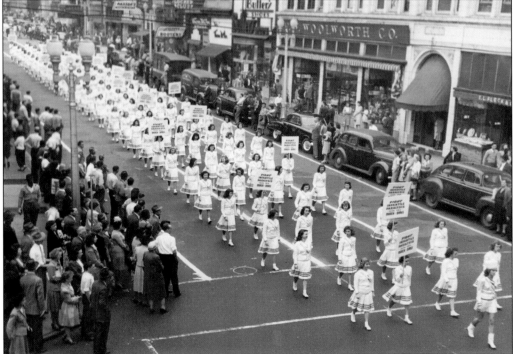

The Landon High School Lionettes are seen here in the 1940s marching and carrying signs that read, "Fight infantile paralysis, join the March of Dimes." The Lionettes were nationally known for their precision marching and intricate formations. They performed in many locations and for a variety of causes. Polio was the scourge of the nation at this time and remained so until the development of the polio vaccine in 1955. (Courtesy of the Landon Alumni Association.)

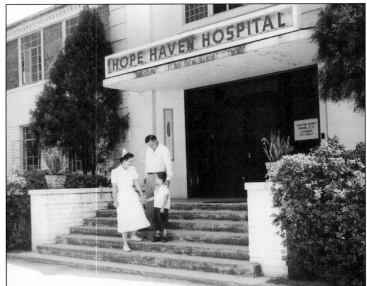

Hope Haven Hospital opened its Atlantic Boulevard location in 1939. Its original Trout River location opened in 1926 and was designed to serve malnourished children and those infected with tuberculosis. The mission of the new hospital, seen here, was to serve the needs of children with poliomyelitis and osteomyelitis. (Courtesy of Hope Haven.)

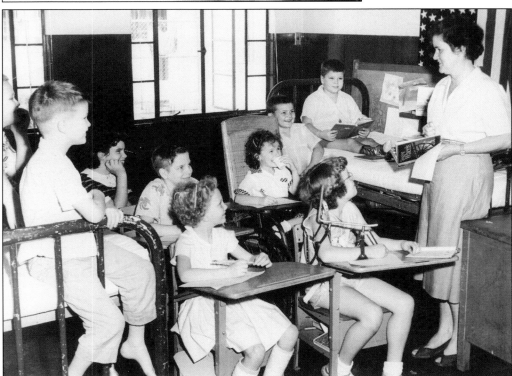

This photograph was taken at Hope Haven Hospital's next location on Atlantic Boulevard, seen also in the previous picture. Notice the open casement windows, since, like most mid-20-century structures, the original building had no air-conditioning. The teacher is Marie Hurst, and the students are unidentified. Hope Haven not only offered medical care but also provided education for its small patients as they recovered from the debilitating effects of polio and other diseases. (Courtesy of Hope Haven.)

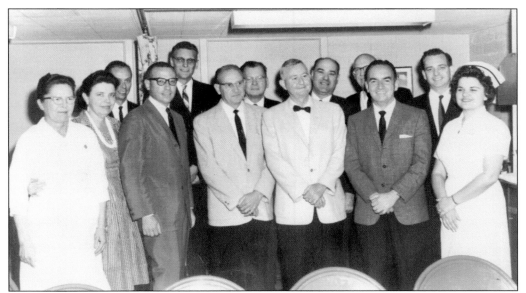

Seen here is the Hope Haven "Cleft Palate Team" in 1955. The individuals are, from left to right, identified by handwritten notes on the back of the photograph as follows: (first row) Sara McCullough (CMS nurse), unidentified, Bernie Reege, MD (surgery), Dr. Charles Ammons (surgery), Dr. Skinner (pediatrics), Bernard Moyus, MD (surgery), and unidentified (CMS nurse); (second row) unidentified, Dr. William Bush, Dr. Riley (prosthodontics), Dr. Poirrier (dentist), Dr. Bryan Carrol (oral surgery), and Dr. Neal Potts (orthopedic.). (Courtesy of Hope Haven.)

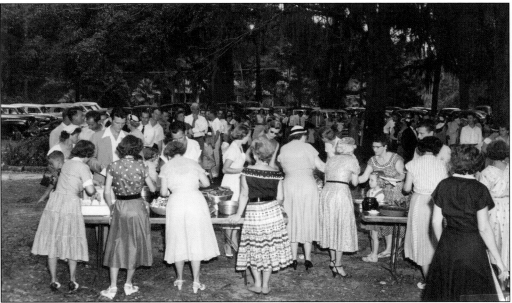

In this 1952 photograph, the congregation of St. Paul's Episcopal Church is seen enjoying a Sunday picnic under the trees. The church membership increased greatly during 1952–1954, and a professional fundraiser was hired for the capital campaign to fund the building of the new brick church. This picture was taken in the same location as the photograph on the cover. (Courtesy of St. Paul's Episcopal Church.)

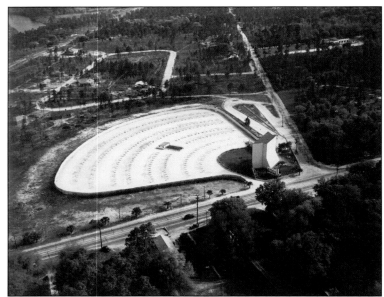

This is an aerial view of the Atlantic Drive-In movie theater soon after it opened in 1939. It was located on the southeastern corner of Atlantic Boulevard and Bartram Road, just east of Hope Haven Hospital. Today, the drive-in has been replaced by a Publix supermarket shopping center. (Courtesy of the State of Florida Archives.)

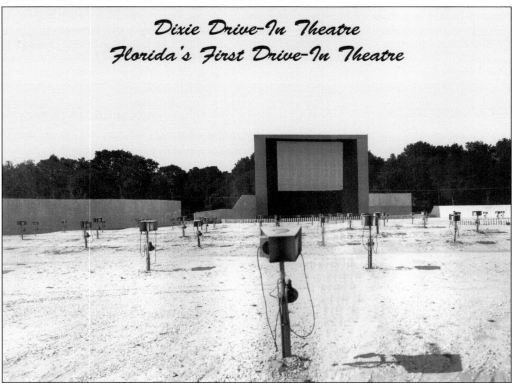

Despite being advertised as "Florida's First Drive-In Theatre," the Dixie Drive-In was actually the second one in the state, since Miami had opened one in 1938. The one pictured above was, however, the first one in Jacksonville, opening in 1939. It was originally called the Jacksonville Drive-In, and in 1945, it was renamed the Atlantic Drive-In. Dixie Drive-Ins operated the theater through 1969; in 1975, it was closed forever. (Courtesy of Lynn Denning Costner.)

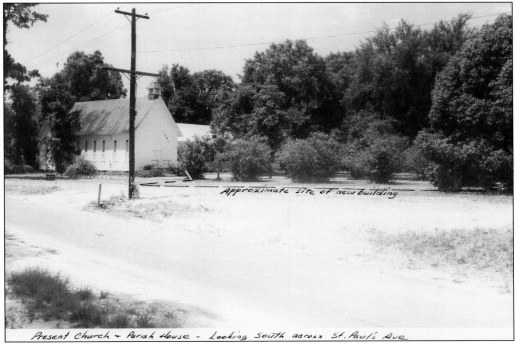

Present Church & Parish House - Looking South across St. Paul's Ave

Located west of the drive-in movie theater site seen on the previous page, this picture shows the original 1888 building of St. Paul's Episcopal Church on St. Paul's Avenue. The photograph was taken in the early 1950s, prior to the construction of the new, much larger, brick church. The little Carpenter Gothic church was moved, via barge, to a new location next to the Museum of Science and History. Later, in 1994, it was moved again to its current resting place in Fletcher Park on Atlantic Boulevard, west of San Marco Square. The photograph below shows the original rectory of the church. At that time, Atlantic Boulevard was still a two-lane road and had not yet been widened to its present width. As noted on the bottom of the picture, the photograph documents the newly constructed access road. (Both, courtesy of St. Paul's Episcopal Church.)

Rectory showing new access road - Looking south across Atlantic Boulevard

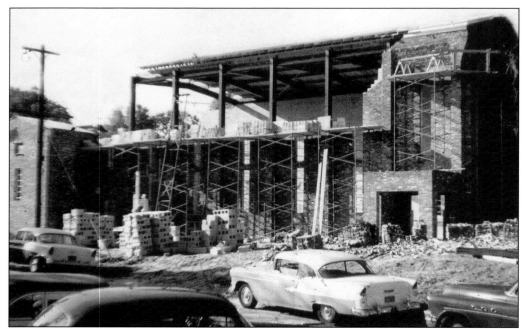

St. Paul's Episcopal Church's new building is seen here in the 1950s, partially completed. The picture below depicts the ceremony of placing a time capsule in the building. The participants are, from left to right, Fr. Jim Orth, Bishop Frank A. Juhan, and an unidentified representative from the diocese. To date, the time capsule remains unopened. Behind the gentlemen is the cornerstone of the building, which reads, "St. Paul's Episcopal Church, A.D. 1955." The two-tone automobile in the foreground above is a 1956 Chevrolet. (Both, courtesy of St. Paul's Episcopal Church.)

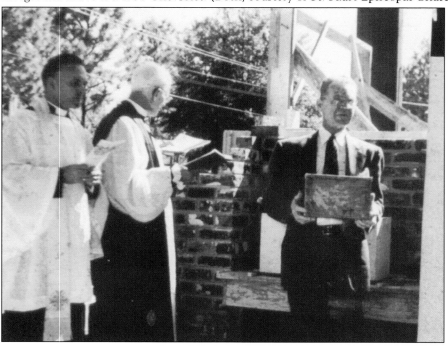

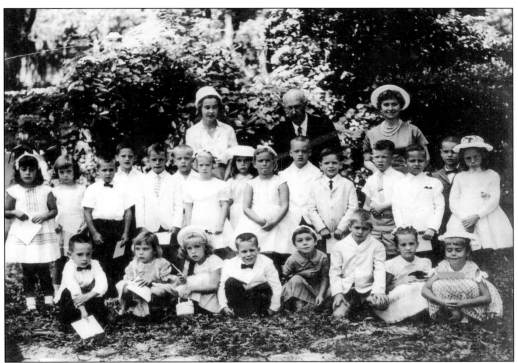

This is a 1950s photograph of a Sunday school class at St. Paul's Episcopal Church. The members are, from left to right, (first row) Jeffrey Carbonneau, Suzy Getchell, Sandy Hampton, unidentified, Debbie McGuigan, Charles Harding, Patty Laing, and Noney McMurray; (second row) Joan Graves, unidentified, Al Russell, Scotty Edwards, Chris White, Lee Lester, Cheryl McNair, Lisa Smyth, Jill Sidwell, Brian Garcia, Paul Myers, Paul Hendricks, Chuck Paul, Kim Myers, and Kathleen ?; (third row) Ruth West, Ed London, and Peggy Young. The photograph below shows the St. Paul's Players in costume for an unidentified play in the 1950s. The performers are unidentified except for "Billie" Bunter (at the far left with parasol) and Steve Hellmuth (the gentleman between the two ladies. (Both, courtesy of St. Paul's Episcopal Church.)

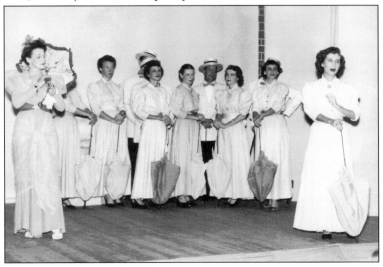

This home on Oak Haven Road is one of the oldest surviving houses in Jacksonville. It was built by and for Francis Richard III, son of Francis Richard II. Frances Richard I had an original Spanish land grant consisting of approximately 16,000 acres in what is now Arlington. At some point, Francis Richard III moved his family south of the Arlington River into this beautiful Gothic-style home. The exact date of his move is unknown, but a letter survives that Francis Richard II wrote in 1837. In this letter, he mentions the construction of a house for his son Francis III, probably the structure pictured here. In 1908, the heirs of Charles G. Hulbert (who purchased the house from Francis Richard III) sold the property to William John and Lillie Campbell Holden, pictured below. Their family retained the home for most of the remainder of the 20th century. (Both, courtesy of St. Paul's Episcopal Church.)

This photograph was taken on the occasion of John and Lillie Campbell Holden's 50th wedding anniversary on July 4, 1939. The participants are, from left to right, (first row) Lillie and John Holden; (second row) Lillian Heston and John Holden; (third row) George Holden, Violet Peck, and Nell Richards. (Courtesy of "Dede" Dowling Rehkopf.)

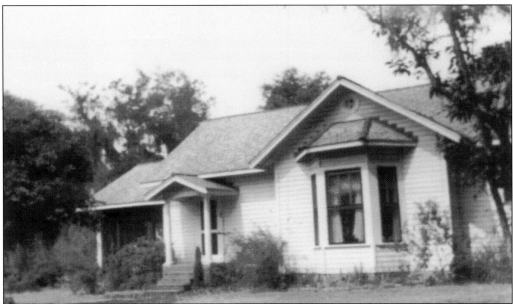

Ann and George Holden's home is seen here. It was located on Campbell Avenue. Next door to this house was the original community meeting place, and Betty Dowling called it the "Ingénue Club." At the end of Campbell Avenue is a huge oak tree that is pictured on page 64. (Courtesy of "Dede" Dowling Rehkopf.)

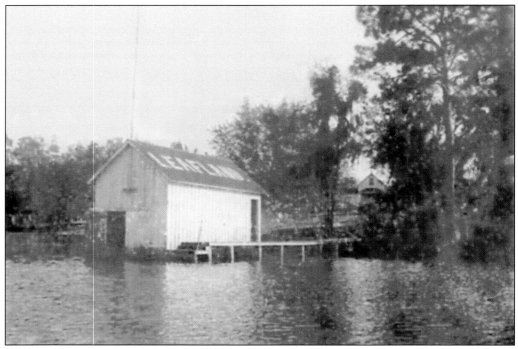

This rare 1800s photograph shows the dock and storage building for the property know as Leafland, owned by the Holden family. Their house is visible in the distance. According to an account written by Lillian Holden, Leafland was part of the Richard Plantation, a large tract of land that included all the property between Little Pottsburg Creek and the Arlington River. The body of water seen here is the Arlington River. (Courtesy of "Dede" Dowling Rehkopf.)

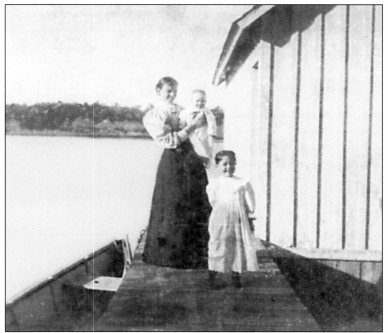

In this late-1800s photograph, Lillie Holden is seen holding baby George. She is flanked by young Nell Holden. They are standing on the dock next to the Leafland storage building, seen in the previous picture. Visible in the distance is the area of Clifton. Note the rowboat docked next to them. (Courtesy of "Dede" Dowling Rehkopf.)

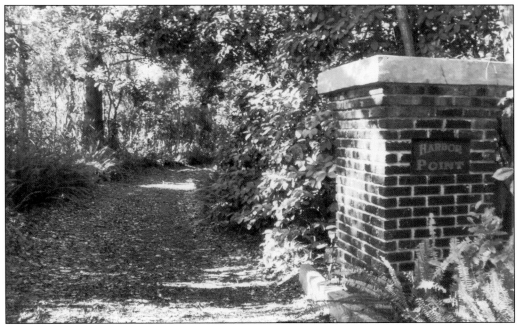

This is one of two beautiful and inviting brick gate pillars that define the entryway to Harbor Point, the Campbell-Gibson property located at the end of Campbell Avenue. This tree-shaded lane looks little different than it did more than 100 years ago when William John Holden built his home here in 1898. The house he built still stands, well hidden and tucked away, at the end of the driveway. The house is pictured below and is still owned and occupied by the family. Several of the houses in this area off Atlantic Boulevard are still owned and cared for by descendants of the early Southside settlers who built them. (Both, courtesy of Merilyn Kaufmann.)

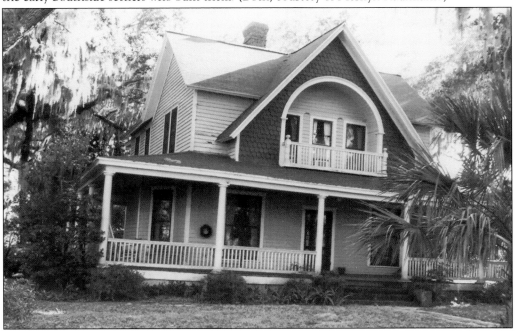

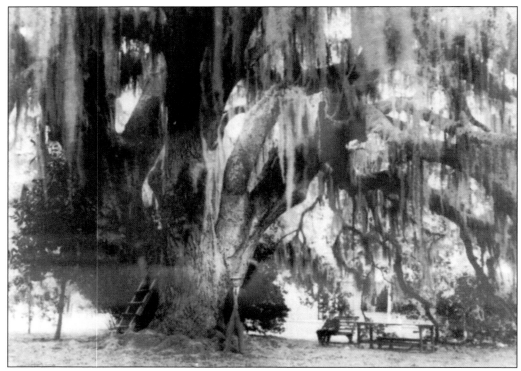

The massive tree seen in these two photographs is still alive and thriving on Campbell Avenue. The picture above was taken in the late 1800s; the photograph below was taken more than 100 years later. The tree appears to be little changed, but the surrounding property is vastly different. No longer a rural, wooded area, it is now a small, platted subdivision. In the above picture, two gentlemen are seen enjoying a pastoral afternoon in the shade. The man standing beside the tree is unidentified but could possibly be John Holden. The man on the bench is unidentified. (Both, courtesy of St. Paul's Episcopal Church.)

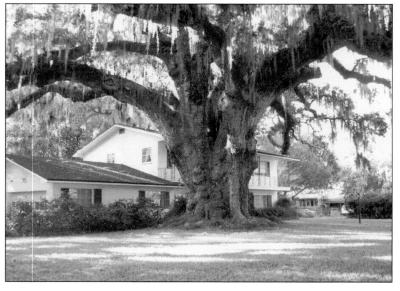

This beautiful structure, called Marabanong, still stands in Empire Point. English astronomer Thomas Basnett built it in 1876 on the site of a previous structure that burned. His wife, Eliza Wilbur, was a noted scientist from New York. While living at Marabanong, she patented a large astronomical telescope and was working on a design for an airplane.

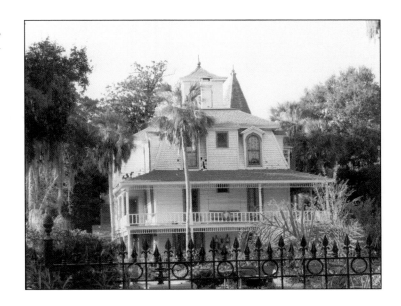

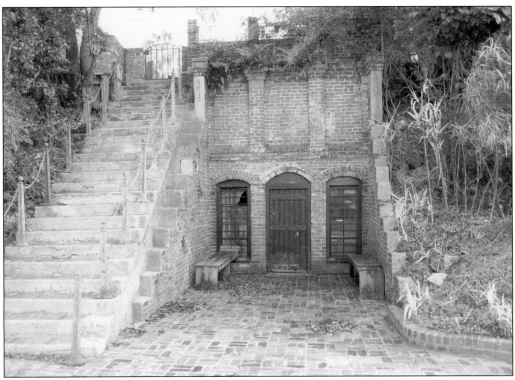

The only part of the 1850s structure to survive the fire was a brick underground tunnel whose entrance near the river can still be seen today. It has always been referred to as a wine cellar, but its actual purpose remains a mystery. It connects to the kitchen of Marabanong's main house and rumors abound about it being used as an escape route during turbulent times or as a place to unload pirate booty.

Grace Wilbur Trout moved to Jacksonville with her husband, George, and they purchased beautiful Marabanong. Grace was a successful activist, orator, politician, and novelist long before moving to Florida. In Illinois, she led the campaign to give women the right to vote. In 1913, Illinois was the first state east of the Mississippi to give women that right, which was seven years before the 19th Amendment was passed. She traveled rough dirt roads on automobile tours and often gave speeches directly from her vehicle. In Florida, she was the first president of the Jacksonville Planning and Advisory Board and president of the Garden Club. At Marabanong, she and her husband kept a virtual zoo of animals, which included crocodiles, deer, and peacocks. The picture below shows the iron entrance gates to the property, complete with "Marabanong" spelled out across the front. (Left, courtesy of the Library of Congress.)

Three

HENDRICKS AVENUE AND SAN JOSE BOULEVARD

DEVELOPMENTS WITH A SPANISH THEME

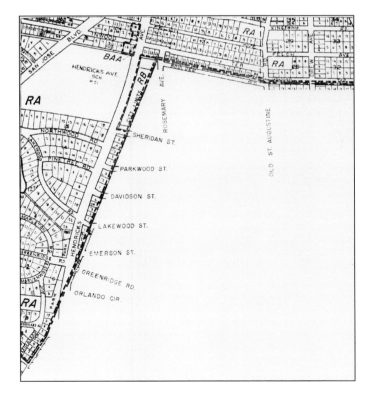

This zoning map documents the development along Hendricks Avenue in the 1950s. The blank area is outside the city limits. The Hendricks Avenue Elementary School property is clearly visible on the top right of the picture, and Old St. Augustine Road appears to vanish into the still rural area outside the city limits. (Courtesy of the City of Jacksonville.)

In Jacksonville's very early days, before the streets were paved, residents had to cope with wagon roads that became a sea of mud during heavy rains. This photograph shows the tire chains that were used in Northern states for navigating through snow and ice and that also proved useful in helping Southside's pioneers navigate deep ruts and muddy roads. Above is Hilda Peterson on the right, along with two unidentified friends. (Courtesy of the Peterson family.)

This is the crest for the San Jose Development, founded in 1914 by Claude Nolan. Nolan, who also owned a Cadillac dealership, believed that road construction and the increasing importance of the automobile would foster real estate development in Jacksonville's outlying areas. In the 1920s, Nolan became the first person to drive an automobile to Key West. Over 50 miles of the journey involved driving on railroad trestles.

This early photograph of the First Baptist Church of South Jacksonville congregation was taken near the corner of Kipp and Home Streets, near Hendricks Avenue. Today, this area is mostly vacant land, and the property sits only a few blocks north of Interstate 95. The First Baptist Church of South Jacksonville was the forerunner of today's Southside Baptist Church. (Courtesy of Southside Baptist Church.)

This is another early photograph showing members of the First Baptist Church of South Jacksonville. During those first years, the garage building behind them served as the meeting place for their Sunday school classes, since better accommodations had yet to be constructed. Later, the First Baptist Church of South Jacksonville merged with the First Baptist Church of San Marco to form the Southside Baptist Church. (Courtesy of Southside Baptist Church.)

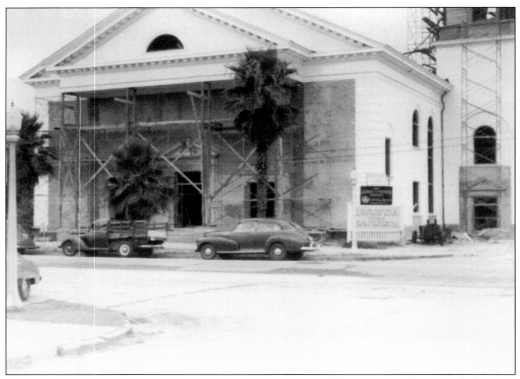

This 1950s-era photograph shows the Southside Baptist Church during construction. This picture shows the current sanctuary and part of the beautiful steeple. The location is the northwestern corner of the intersection of Atlantic Boulevard and Hendricks Avenue. Note the old slat-sided pickup truck parked in front of the steps. (Courtesy of Southside Baptist Church.)

Photographed coming down the front steps of the Southside Baptist Church are, from left to right, Donald Zahn, Ruby Miller, and Beulah McClanahan. This picture was taken some time in the 1950s, and the building visible in the distance, located on the other side of Hendricks Avenue, appears to be a service station. (Courtesy of Southside Baptist Church.)

This is the "Beginner B," or preschool, Sunday school class at Southside Baptist Church. The participants are unidentified. The time period is the 1940s, and the street visible through the windows may be Hendricks Avenue. Note the open window and the large fan suspended in the upper left corner, a testament to the conditions that existed in Florida in the days before air-conditioning. (Courtesy of Southside Baptist Church.)

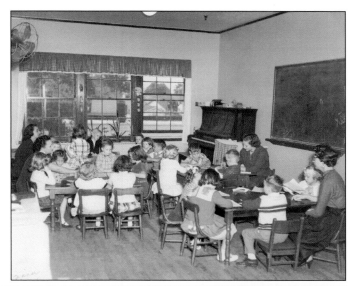

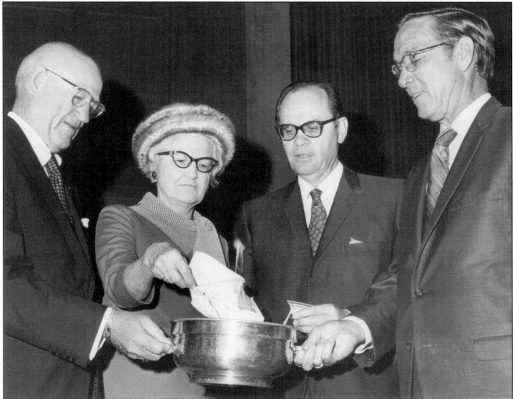

The ceremonial burning of the mortgage for the Southside Baptist Church on November 1, 1970, is seen here. The participants are, from left to right, Brown Whatley, Lucile Alexander, Pastor Dr. Malcolm Knight, and Tique Wilcox. Whatley was an original partner in the real estate firm of Stockton, Whatley, Davin, and Company. Brown L. Whatley Memorial Park on Hendricks Avenue is named in his honor. (Courtesy of Southside Baptist Church.)

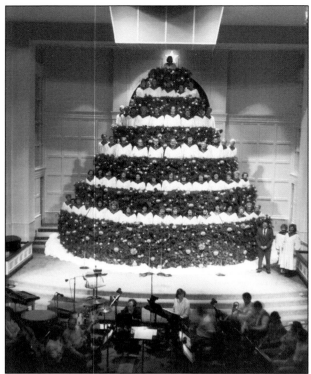

A beloved Christmas tradition is the performance of the Southside Baptist Church's Singing Christmas Tree. The tree is made up of almost one hundred choir members, and their voices fill the space. Vocal performances by younger choir members are also featured. The event began in the late 1970s, and today, although tickets are free, a reserved seat is a necessity because the event is so popular. In addition to the Singing Christmas Tree, the church has "No Room at the Inn," a display of Nativity scenes loaned by church members. The left photograph was taken in the 1980s. The picture below was taken in the 1940s and shows members of the congregation standing on the steps of the Southside Baptist Church. The church members are unidentified. (Both, courtesy of Southside Baptist Church.)

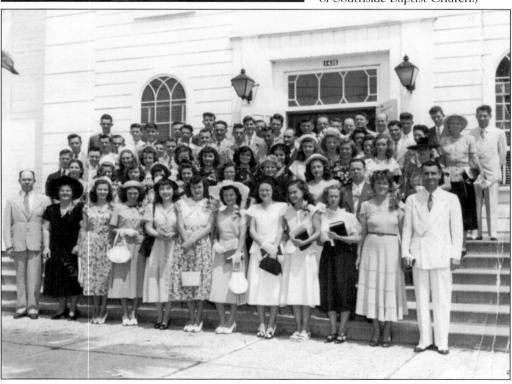

Seen here taking care of his baby sister Sylvia is young Miller Rousseau. They are standing on the western side of Thacker Avenue. Thacker Avenue runs parallel to Hendricks Avenue on the east. The building in the far distance is Landon High School, and the small building across the street is an unidentified business. (Courtesy of Miller Rousseau.)

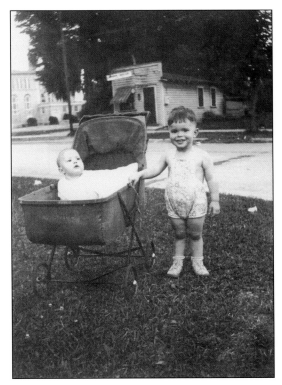

This late-1930s photograph was also taken on Thacker Avenue in the same front yard. P.M. Rousseau is shown here with his firstborn, Miller. The house that the Rousseaus lived in was moved from its Thacker Avenue location in the 1980s and relocated to a new resting place in Green Cove Springs. (Courtesy of Miller Rousseau.)

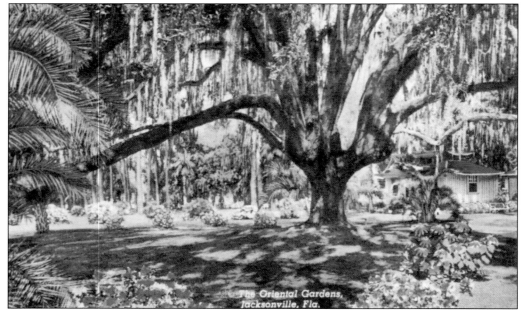

Oriental Gardens was a popular attraction located off Old San Jose Boulevard. It began in 1937, the brainchild of Riverside resident George W. Clark, who used the 18 acres as a place to plant the overflow from his botanical gardens. It was advertised as "The Singing Gardens of Jacksonville." At Oriental Gardens, visitors could stroll around sunken pools, fountains and flowering plants and over scenic bridges—all while listening to the sounds of musical chimes.

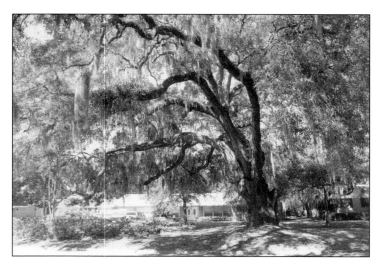

This is the same tree as the one in the previous postcard but photographed long after Oriental Gardens closed in 1954. When the site of the attraction became a platted subdivision, this tree was preserved. It is missing at least one of its major branches and is showing its age; however, the tree soldiers on. It is now the centerpiece of the cul-de-sac at the terminus of Oriental Gardens Drive.

Southside Methodist Church, located at the northern split of Hendricks Avenue and Old San Jose Boulevard, was conceived in 1938. On Easter Sunday, April 9, 1950, the church opened in the building seen here. In 2011, the steeple was refurbished, providing a rare period when the concrete finials could spend time on the ground. The church building is located is across the street from the former entrance to Oriental Gardens.

Four concrete finials line the walkway leading to the front entrance of Southside Methodist Church. Looking much larger than they do in their normal post atop the steeple, these finials appear to be waiting patiently until they can once again take their place high above the church, overlooking a panoramic view of the San Marco and San Jose areas.

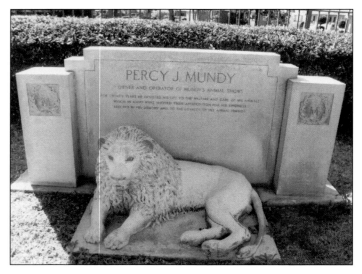

Percy Mundy, a wild-animal tamer who performed at Dixieland Park, was clawed so frequently that he had only one eye. When he retired, he sold his show to Robinson Amusement Company for $20,000 and went on to become a real estate developer on Jacksonville's Southside. Mundy purchased land south of today's Miramar Shopping Center and built himself a home known as Hollywood Park. He platted the area and called it Ardsley.

This photograph was taken in 1942 at Mr. Whitehead's grave in Oaklawn Cemetery. The young boy pictured is his grandson David Whitehead. Oaklawn Cemetery is located on Hendricks Avenue, north of University Boulevard West. It is the final resting place of several notable citizens, including Florida governors William Haydon Burns and Harrison Jackson Reed, major-league baseball player Don Bessent, and animal tamer Percy Mundy. (Courtesy of S. Andrews.)

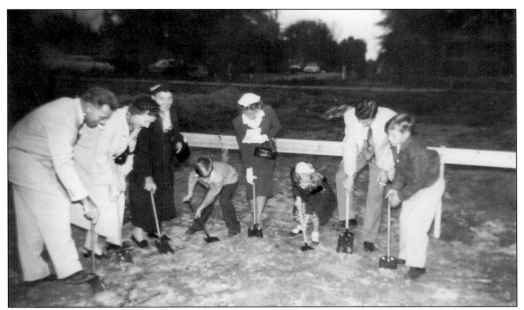

This photograph shows the ground-breaking for the St. Mark's Lutheran Church Educational Building, located on the corner of Hendricks Avenue and London Road. The participants are, from left to right, John Peterson, Edith Peterson, Hilda Peterson, Howard Vollers Jr., Tootsie Vollers, Barbara Vollers, Howard Vollers Sr., and Chris Caldwell. The street visible behind them is London Road at its intersection with Birmingham Road. (Courtesy of the Peterson family.)

A gathering at St. Mark's Lutheran Church is seen here. In the foreground is Mrs. Krueger, speaking with an unidentified gentleman. The other participants are also unidentified. The property on which the church building stands was purchased on August 12, 1947. This 1950s photograph must have been taken only a few years after the church building was finished. The original church was located on the corner of Hendricks Avenue and Lasalle Street. (Courtesy of the Peterson family.)

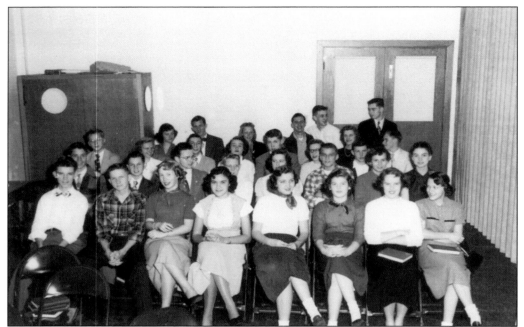

This is a 1950s photograph of the Luther League Youth Group from St. Mark's Lutheran Church. The members are, from left to right, (first row) Cliff Bird, John Schwarz, Nancy Caldwell, unidentified, Carol Nease, Nancy Leake, Sally Seepe, and Anadele Krueger; (second row) John Peterson, Merritt Bird, Bruce Linebaugh, Jim Barker, Gerry Anderson, Walter Weinberg, Susan Linebaugh, and Wilhelmina Rist; (third row) C.V. Caldwell, Doris Branam, "Dickey" Hardin, Mary Ethel Hutto, Norman Malmberg, unidentified, Pierce Johnson, and unidentified; (fourth row) unidentified, Jack Nease, unidentified, Henry "Foots" Courtney, Sid Malmberg, unidentified, and John Glass. The photograph below shows Mrs. Boyd's fifth-grade class from Hendricks Avenue Elementary School for the year 1949–1950. Mrs. Boyd is in the top center, but the students are unidentified, except for Ken Peterson, located second from left in the third row. (Both, courtesy of the Peterson family.)

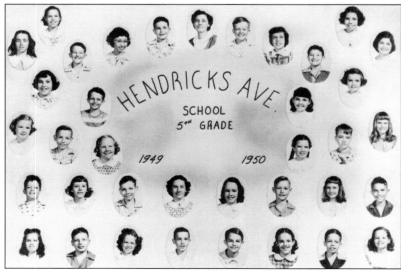

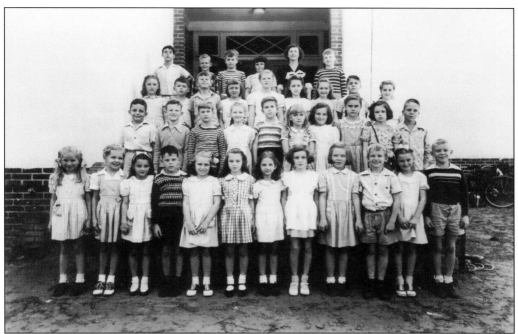

This fourth-grade class at Hendricks Avenue Elementary School was photographed in December 1946. The teacher is Mrs. Varnes. She is standing in the back row. The students are, from left to right, (first row) three unidentified, Martin Harrell, Mary Jane Burns, Betty Lou King, Elizabeth Lee, Ada Leigh Wall, and Wilma L'Engle. The other students are unidentified. Ada Leigh Wall went on to become the 1955 valedictorian at Landon High School. The photograph below is from an unknown play performed at Hendricks Avenue Elementary School in the mid-1940s. Judging by the petals on some of the costumes, the pupils appear to be portraying flowers or plants. The only student identified is Wilma L'Engle, located third from the left in second row. (Both, courtesy of Wilma L'Engle.)

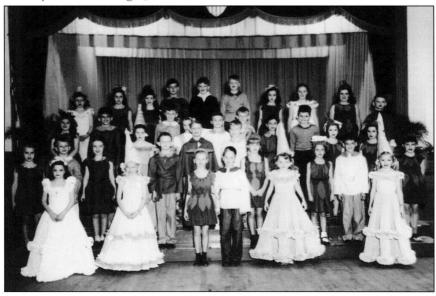

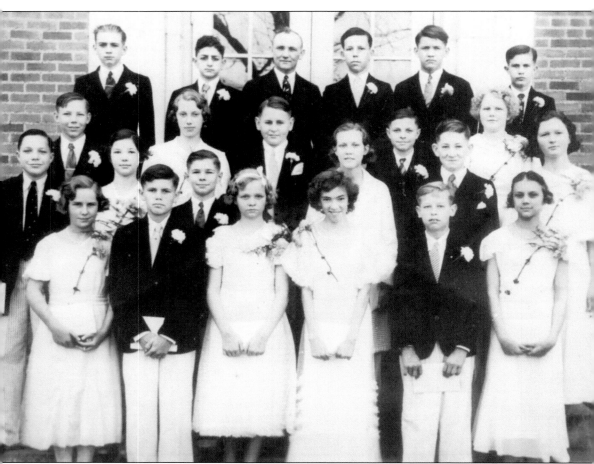

This 1939 photograph of a confirmation class was probably taken on the steps at St. Mark's Lutheran Church at its original location on Lasalle Street and Hendricks Avenue. Most of the participants are unidentified, with the exception of Hilda "Tootsie" Peterson (on the left in the first row) and Howard Vollers (third from the left in the second row). A few years later, Hilda and Howard married, and they raised a family. Their wedding day was December 6, 1941. A poignant account written by Edith Peterson describes the wedding as "beautiful" and adds, without further explanation, that no one could have foreseen the event that was about to unfold in less than 24 hours. That event was destined to change the lives of every American in some way: the attack on Pearl Harbor. (Courtesy of the Peterson family.)

This is a 1950s photograph of the St. Mark's Lutheran Church baseball team. They are, from left to right, (first row) Jimmy Bass, two unidentified, Ted Shipp, and unidentified; (second row) four unidentified, John Peterson, manager Crutsie Bass, Merritt Bird, and Cliff Bird. The person in the far background holding the bat is unidentified. (Courtesy of the Peterson family.)

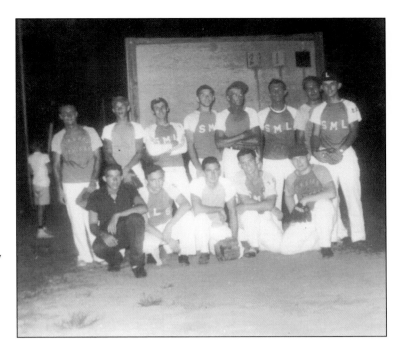

John T. Joyner is seen here standing in the front yard of his home on Cordova Avenue. This street is part of the Granada subdivision, which opened in 1926. Granada featured paved roads and ornamental streetlights. When the real estate bubble burst, Granada remained mostly vacant until after the Depression. The automobile in the picture is a 1954 Buick. (Courtesy of the State of Florida Archives.)

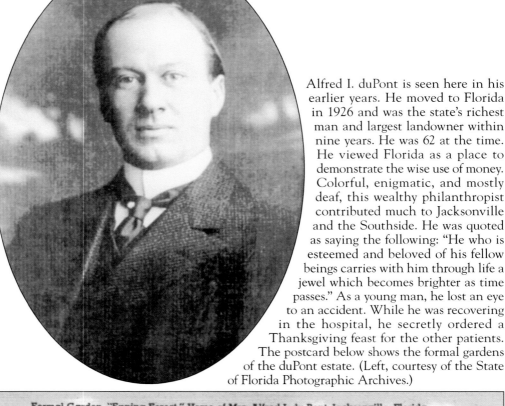

Alfred I. duPont is seen here in his earlier years. He moved to Florida in 1926 and was the state's richest man and largest landowner within nine years. He was 62 at the time. He viewed Florida as a place to demonstrate the wise use of money. Colorful, enigmatic, and mostly deaf, this wealthy philanthropist contributed much to Jacksonville and the Southside. He was quoted as saying the following: "He who is esteemed and beloved of his fellow beings carries with him through life a jewel which becomes brighter as time passes." As a young man, he lost an eye to an accident. While he was recovering in the hospital, he secretly ordered a Thanksgiving feast for the other patients. The postcard below shows the formal gardens of the duPont estate. (Left, courtesy of the State of Florida Photographic Archives.)

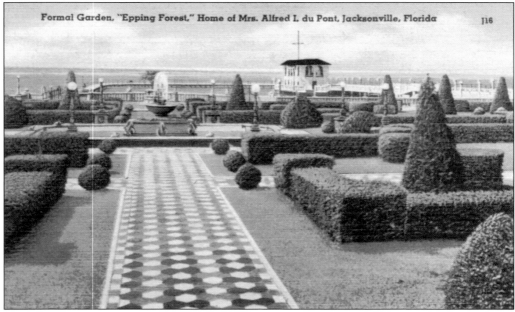

Formal Garden, "Epping Forest," Home of Mrs. Alfred I. du Pont, Jacksonville, Florida 116

Epping Forest was the estate developed by Alfred I. duPont. The house on the right, built in the 1920s, is a combination of Gothic, Spanish, Renaissance, and Baroque styles. The grounds included gardens, a lion's-head fountain, underground tunnels, and a cannon that Mr. duPont fired off at 5:00 p.m. daily. This was intended to be a show of force to warn away any Germans he feared might come up the river in the post–World War I era. (Courtesy of the State of Florida Photographic Archives.)

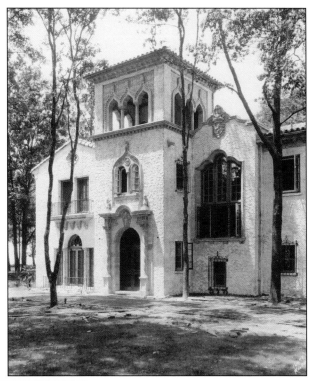

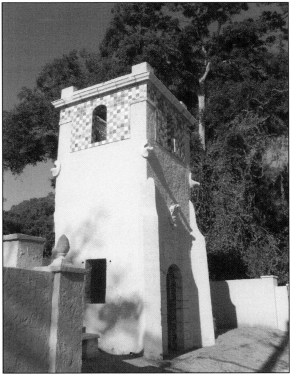

This stucco, brick, and tile tower is the last of four that were built in the 1920s. The towers marked the boundaries of the new San Jose Development, described as "Jacksonville's Suburban Masterpiece." Unfortunately, the vision exceeded the reality. When the Florida land boom went bust, so did the San Jose Development. Only 31 houses and a hotel were built, and many of the houses remained vacant for many years.

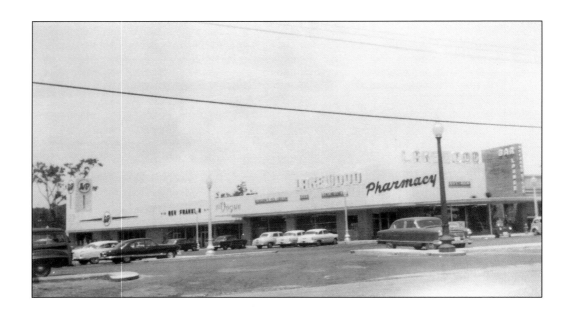

The Lakewood subdivision was developed between 1946 and 1961 by Walter Crabtree. Some of this property surrounds picturesque New Ross Creek, which winds its way through the northwest section. Walter Crabtree was a real estate developer and builder who owned his own lumber company and built the Lakewood Apartments. The above photograph depicts the north side of the Lakewood Shopping Center during the 1950s, with the A&P Grocery store visible on the left. The photograph below shows the original Sunday school building for the San Jose Baptist Church. San Jose Baptist Church opened in January 1955 and is located just down the street from the Lakewood Shopping Center at 6140 San Jose Boulevard. (Both, courtesy of the Southside Baptist Church.)

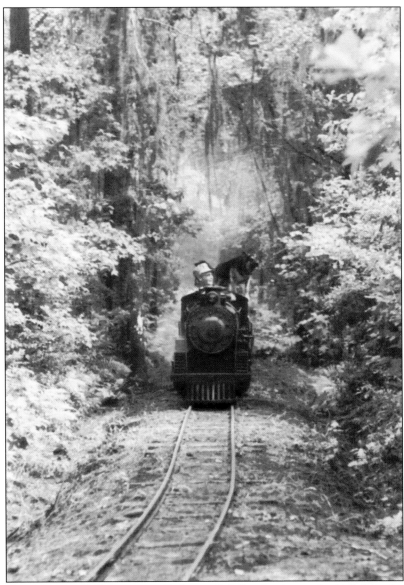

One of the most memorable locations on Jacksonville's Southside was the little Mandarin train. It was located on the southwest corner of Loretto Road and San Jose Boulevard. The train was built by Mr. Ward, a machinist at the Jacksonville Naval Air Station. He is seen in this photograph along with his German shepherd. The attraction was a 16-inch-gauge railroad, with three small adults fitting on each seat of the train. Ward owned the beloved business for 27 years. He acted as engineer and drove the train, and his wife worked taking tickets and running the small gift shop. When consolidation happened in 1968, Mandarin became part of the city of Jacksonville and subject to its laws. A law governing small attractions did not exist, only a law meant to regulate large circus operations. Thus, running the Mandarin train became cost-prohibitive. Mr. Ward attempted to have the law changed, but he was unsuccessful. So, after 27 years, he pulled up the tracks and closed the business. But the "little train" lives on in the memories of many Southside residents. (Courtesy of Tom Markham, photographer, and John Leynes.)

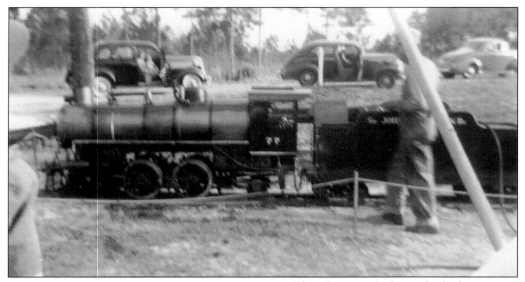

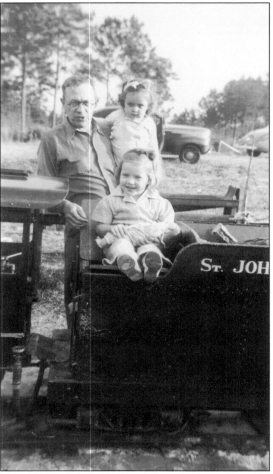

This photograph shows the little Mandarin train ready for another run. In the background is a line of cars that brought children from all parts of the city to this favorite attraction. At the time, Mandarin was a long drive from most places in Jacksonville. The gentleman in the engineer's hat is probably Mr. Ward, although there were other engineers over the years. This picture was taken in the spring of 1941. (Courtesy of Wilma L'Engle.)

A trip to the little train was always an eagerly anticipated event. Frank L'Engle is seen here enjoying time with his daughters. Claudia, who is about one and a half years old, is being held in his arms, while four-year-old Wilma sits just behind the engine of the Mandarin train, holding her doll. Frank L'Engle died in 1946, about five years after this picture was taken. (Courtesy of Wilma L'Engle.)

Four

PHILIPS HIGHWAY
THE TOURISTS' GOLDEN ROAD

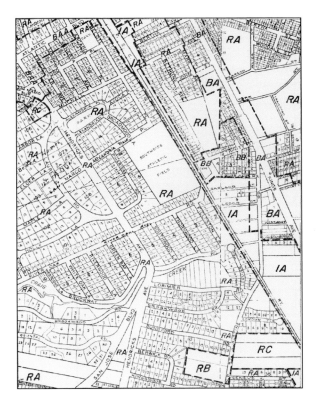

Today, Philips Highway is a 17-mile-long section of US 1 named after Judge Henry Bethune Philips (and often misspelled with two Ls). The road technically begins at Interstate 95, (Exit 348) and ends at the St. Johns County line. Prior to the building of Interstate 95, Philips Highway merged seamlessly with Kings Avenue (seen on the right side of the map) and provided a direct route for tourists headed south. (Courtesy of the City of Jacksonville.)

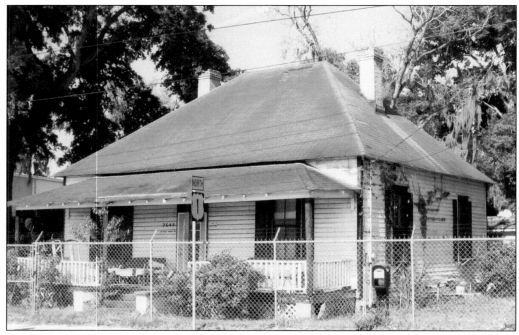

One of the last survivors of the community of Philips is this house at the corner of Jerusalem Street and Philips Highway (then called Kings Avenue). Built in 1909, it was part of the Springleton homestead (Lansbery patent) in South Jacksonville. In the early 1900s, the road was lined with many such buildings.

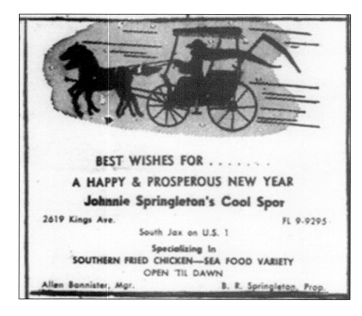

A popular restaurant for many decades was Springleton's Café, owned by John Franklin Springleton. He was the son of Charles and Mary Springleton and grandson of Ned Springleton. This 1960s advertisement from the *Florida Star* gives its address at 2619 Kings Avenue. Today, this site is home to Overby's Automotive and is next door to the house in the previous picture. (Courtesy of the *Florida Star*.)

This map, taken from a brochure for the popular restaurant Carriker's, extols its location in "South Jacksonville's $5,000,000.00 Motor Court Area." Small tourist motels lined Philips Highway during the golden age of tourism in Jacksonville. Few of these establishments exist today, and those that do have been repurposed. Carriker's Restaurant was located directly across Kings Avenue from John Street in the middle of the El Verano Motor Court. (Courtesy of J.W. Carriker and J. Waits.)

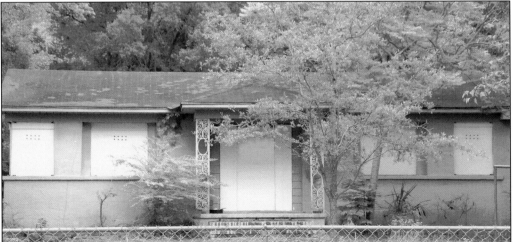

Some buildings from the El Verano Motor Court still exist but are no longer on Philips Highway. Several of the small tourist cottages were relocated to other areas on the Southside, with many as far away as Julington Creek. They were redesigned, in part by removing one of the two front doors, and now these buildings serve as private homes. The one seen here appears to be awaiting a new owner. (Courtesy of Stephen J. Smith.)

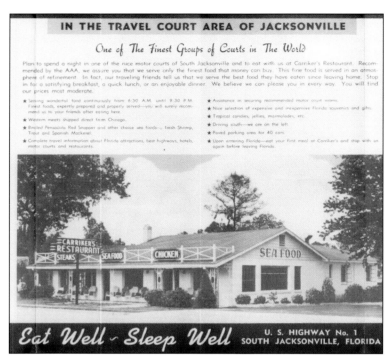

Carriker's Restaurant is seen here in a 1950s brochure. This establishment is fondly remembered by many Jacksonville residents and by many tourists who passed through the city's "travel court area." This building was razed during the construction of the interstate highway system. Today, this land is located where Interstate 95 and Philips Highway merge. (Courtesy of J.W. Carriker and J. Waits.)

Across the street from Carriker's Restaurant was another popular dining establishment, Biser's Seafood Restaurant, which once had a downtown location. Biser's was located on the corner of Philips Highway and John Street, and this photograph shows the parking area on the rear portion of the property. This photograph was taken from one of Biser's foldout postcards.

Bishop's Motor Court and the pastoral setting it once occupied are now part of the short St. Augustine Road extension called St. Augustine Road East. The property was purchased by the City of Jacksonville. Today, motorists turning west off Philips Highway can drive right through this place that was once "pretty as a picture."

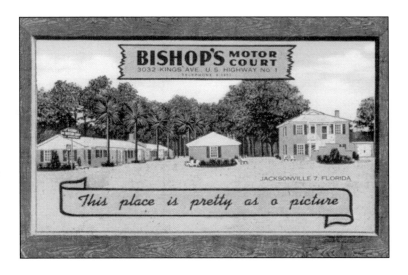

A handwritten account by Edith Peterson, who lived for many years on Community Road, recalls her beloved neighbor Mayme Bishop. She came from Scotland to care for a sick uncle. Mayme Bishop never married. The house seen here was Mayme Bishop's home, and it can still be seen today on the western side of St. Augustine Road. Despite the name, Mayme Bishop is not related to the owners of Bishop's Motor Court.

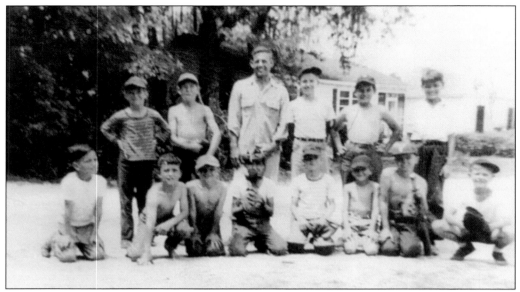

These young baseball players were photographed in the 1940s. They are posing for the camera just off Philips Highway, near the Dan Jones Motor Court. The young men are, from left to right, (first row) Vernon Lafaye, Robert "Bobby" Owens, Bill McKenny, two unidentified, Cecil Everett Reeves, unidentified, and Wendell Morgan Reeves; (second row) Charles "Chuck" McKenny, Thomas "Tommy" Reeves, Buddy Freidlin, unidentified, Skip Velleneuve, and Carl Wiggins. (Courtesy of Thomas Reeves.)

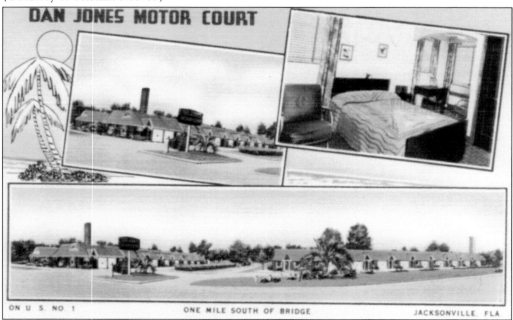

Dan Jones Motor Court, with its distinctively shaped gables over each door, stood on the northwest corner of Philips Highway (then called Kings Avenue) and John Street. This postcard depicts the interior of one of the "35 modern rooms" advertised on the back of the card. The buildings survived into the 21st century but succumbed to the wrecking ball soon afterwards.

This is Emerson Street, looking east from St. Augustine Road, in 1953. The new subdivision being advertised on the sign may be the Pine Forest subdivision, platted in December 1945 by the D&F Development Corporation under R.L. Dowling and W.P. Freeman. This development had 26 lots along both sides of Freeman Road and 13 lots on the west side of Grant Road. (Courtesy of the State of Florida Photographic Archives.)

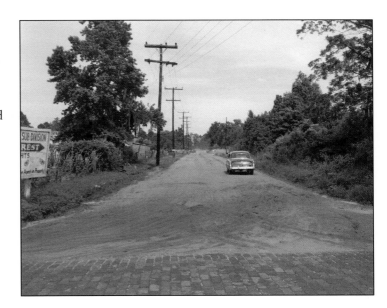

This home is part of the Pine Forest community, which grew out of the Philips community. This area is generally located off Emerson Street between Philips Highway and Hendricks Avenue. Many streets in the neighborhood are named after early residents: Gattis Lane (Abraham Gattis), Session Lane (Andrew Sessions), Thomas Court (William Mott Thomas), Johnson Avenue (Cliff Johnson), and Caljon Road, named for both Calhoun Thomas and Rev. John Jones.

During the early days of the Pine Forest community, the area was primarily wooded land and sparsely developed. One longtime resident remembers the day a bear was killed. The animal was suspended from a tree located on the property where the Southside Church of God in Christ (above) now stands. Many Pine Forest residents came to see the bear and share in the harvesting of the bear meat.

Astride his horse is a young Ken Peterson. It was not long ago that large areas of the Southside retained their rural character. Many acres off Philips Highway and St. Augustine Road remained undeveloped until the latter half of the 20th century. The construction of the interstate highway system (Interstate 95) was the catalyst that significantly changed the face of Jacksonville's Southside. (Courtesy of the Peterson family.)

In the above photograph, the young boy wearing the sombrero is John Peterson, who was born in 1913. He and his dog Max are standing in a field of corn, one of many crops his family raised. For many years, the Petersons owned and worked this farm acreage located on St. Augustine Road between Emerson Street and University Boulevard. At the time, St. Augustine Road was little more than a dirt wagon trail. It was not paved until 1924. The picture on the right shows John Peterson's older brother Philip Peterson, also standing on the St. Augustine Road property. Whether or not Philip is wearing the same sombrero is unknown. (Both, courtesy of the Peterson family.)

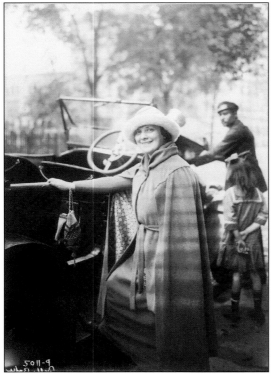

The Peacock Club, seen here on New Year's Eve in 1949, was located south of Emerson Street on Philips Highway. It debuted on October 15, 1946, to "turnaway biz" according to *Billboard* magazine. The opening show was emceed by Bob Russell and featured a June Taylor line, the Whirlwinds, Ricardo and Norma, Buster Burnell, and Sonny Dunham's Orchestra. At least one Landon alum remembers the Peacock Club having televised teen dance parties. (Courtesy of the State of Florida Photographic Archives.)

Former Ziegfeld Follies entertainer Belle Baker, seen on the left in an undated photograph, performed at the Peacock Club in 1948. Her act was reviewed as follows by *Billboard* magazine: "Belle Baker came on with an original welcome song and then launched into a 30-minute song fest de luxe." The *Billboard* article also stated that it was Baker's first stop in Jacksonville and "the folks loved her." (Courtesy of the Library of Congress.)

This hungry turtle was the logo for the Green Turtle Restaurant. It was located on Philips Highway south of Emerson Street. The turtle on the right appeared on a book of matches used to advertise the business. The Green Turtle was a popular Southside dining spot for many years. After it closed, the location was used by Brewmaster's restaurant. Brewmaster's burned down in the early 1980s. (Courtesy of Joe Adeeb.)

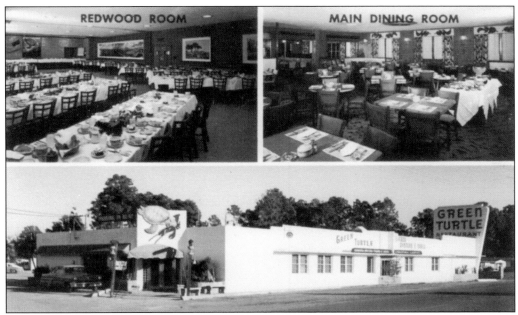

This postcard shows the exterior of the popular Green Turtle Restaurant, plus two interior views. The Redwood Room and the Main Dining Room are invitingly portrayed and certain to entice hungry travelers. Note the green turtle logo from the previous picture, prominently displayed over the main entrance to the restaurant.

The Sunbeam Prison Camp is seen above with an unidentified man demonstrating the use of a foot stock. The prison was located approximately 12 miles southeast of Jacksonville, between Philips Highway and the East Coast Railway. It was the site of Florida's infamous "chain-gang hanging." In June 1932, Arthur Maillefert, a 19-year-old inmate, was strangled by a chain that held him in place. He was unable to stand because his feet had been placed in stocks. His case drew nationwide attention to the abuses in the prison system, and the event was even made into a movie. The picture on the left is the last known photograph taken of Arthur Maillefert. (Both, courtesy of the State of Florida Photographic Archives.)

During the 1930s, prison inmates were often used on road-building crews. The tree seen here is remembered as one of the places where chain-gang prisoners would take their breaks and enjoy the opportunity to get out of the blazing Florida sun and rest for a brief period. This huge tree, located on the corner of Fleet Street and Lakewood Road, lives on today as a quite reminder of that period. (Courtesy of Junius.)

The tree in the previous picture is the same one whose limbs are visible on the far left of this 1950s photograph. This Fleet Street house also survives but is vacant and in a state of disrepair. The land adjacent and north of this home was once farmed by members of the Peterson family. (Courtesy of the Peterson family.)

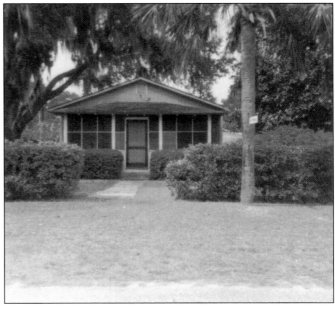

Hilda Peterson is seen here in the side yard of her son John's house on Fleet Street. She is cuddling one of her grandchildren. Behind her is a beautiful backdrop of flowering trees and bushes. The house on Fleet Street was once surrounded by hydrangea bushes and other blooming plants, all lovingly cared for by the Petersons. (Courtesy of the Peterson family.)

The Boy Scouts in this picture are camping near the present location of the Avenues Mall. Standing behind the group is Scoutmaster Dexter Gillingham. The scouts are, from left to right, (foreground, seated in white tee shirt), Wade Gillingham; (first row, seated) Buddy Bass, Tom Sharp (striped shirt), Chris Caldwell, Carl McKinney, Keith Gillingham (with towel), Richard Beckman, unidentified, and Ken Peterson; (back row, kneeling) Lee Evans, Tommy Maloso, and Chuck Summers. (Courtesy of the Peterson family.)

These schoolchildren are all members of "Miss Bessie's" school. It was located in a small bungalow on Felch Street, but the exact location is unknown. Only three students in this photograph are identified. They are Dan Champion (at far left in the first row), Mary Jane Burns (third from the left in the first row), and Wilma L'Engle (second from right in the second row). Miss Bessie was Bessie Hewlett; she is probably the woman standing behind the students. (Courtesy of Wilma L'Engle.)

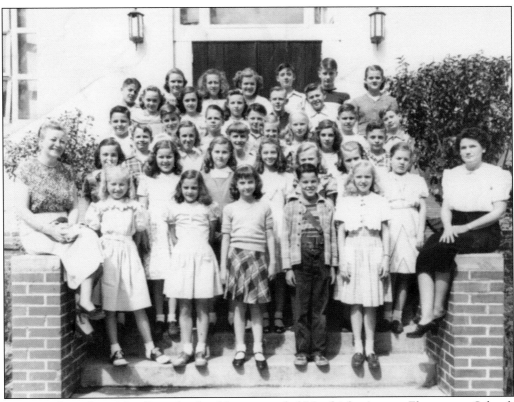

Many students from Miss Bessie's school later attended Hendricks Avenue Elementary School. This is the 1949 sixth-grade class. The principal, Lorena Johns, is seated on the left, and Pearl Martin, a teacher, is seated on the right. The students are, from left to right, (first row) three unidentified, Martin Harrell, and unidentified; (second row) two unidentified, Sarah Monroe, Betty Lou ?, Mary Jane Burns, Wilma L'Engle, and unidentified. The others are unidentified. (Courtesy of Wilma L'Engle.)

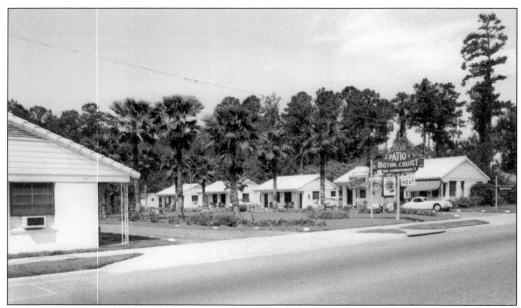

This postcard shows the Patio Motor Court during its heyday in the 1950s. It was located at 3150 Kings Avenue (now Philips Highway). The back of the card states, "A small homelike court," with an "excellent restaurant next door," (probably Adeeb's Ranchero Restaurant). The postcard also boasts of air-conditioning and "TV in rooms." The automobile visible behind the sign is a 1950–1953 XK120 Jaguar, a unique car for that time.

Today, the former Patio Motor Court is a shadow of its former self. The coming of Interstate 95 marked the demise of many such establishments along the former Kings Avenue. Tourists now traveled the interstate and bypassed all the motels and restaurants that used to thrive on the US 1 corridor.

Five

BEACH BOULEVARD
A NEW ROUTE TO THE BEACHES

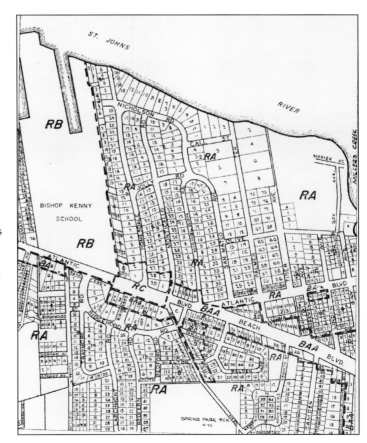

This 1955 zoning map shows Atlantic Boulevard near its intersection with Beach Boulevard. At this time, the city limits ended just a few blocks east. Until Beach Boulevard was extended, Atlantic Boulevard was the main road to the beaches. The grounds of Bishop Kenny School still show evidence of its former life as the Merrill-Stevens Shipyard. (Courtesy of the City of Jacksonville.)

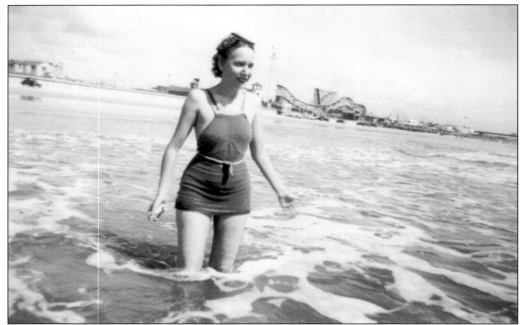

The beach was popular with locals as well as tourists. Pictured above is Southside resident Edith Peterson, enjoying a 1940s summer day in the surf. Clearly visible in the background is the 50-mile-per-hour roller coaster known as "the Beach Coaster" that operated from 1928 to 1949. It was part of an amusement park that included a Ferris wheel. The attraction was located near where the Jacksonville Pier is today, but the park was destroyed by Hurricane Dora in 1964. On the left is a 1920s photograph showing the entrance to the Jacksonville Pier. The young man in the foreground is Tommy Green, a Southside resident who later attended Landon High School. (Above, courtesy of the Peterson family; left, courtesy of the Landon Alumni Association.)

This rare 1950s photograph shows the original Insta-Burger King location on Beach Boulevard. Matthew Burns and his stepson Keith Cramer acquired the rights to George Read's Miracle Insta-Machines. One made multiple milk shakes, and the other, called the Insta-Broiler, cooked 12 hamburgers simultaneously. The restaurant pictured above opened on Beach Boulevard in 1953 and gave Jacksonville bobby-soxers a place to purchase a hamburger for 18¢ or a hot dog for 15¢. In 1954, franchisers James McLamore and David R. Edgerton Jr. opened several Insta-Burger King outlets in Miami. Failing to make a profit, they experimented. They disposed of the Insta-Broiler and created the flame broiler that made Burger King famous. Today, this location at 7146 Beach Boulevard houses Stan's Sandwich Shop. On the right side of the photograph, the rear portion of a 1957 Chevrolet, with its distinctive fins, is visible. (Courtesy of Thomas Reeves.)

Pictured on the left is Charles Benjamin Jones. Jones was one of the first police officers in Pablo Beach. He was well known not only for his police work but also for his avocation as a Boy Scout leader. As such, he became a much-beloved role model and mentor to many young men. Sadly, he was killed in an explosion while on duty. Below is a photograph taken at his funeral, held at Greenlawn Cemetery on Beach Boulevard. The service was attended by many of Jones's current and former scouts, who came to pay their final respects to "their fallen chief." (Both, courtesy of Thomas Reeves.)

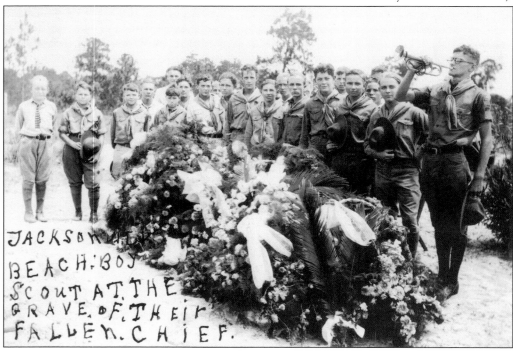

Pictured on the right is a young Ross Farrens, founder of Farrens Tree Surgeons. The photograph below shows Farrens in his later years. Farrens was a role model and an inspiration for a generation of young men from the Southside. Following the loss of his own two sons, Farrens became a leader of the Explorer Scouts, the teenage version of the Boy Scouts. Every summer, he took these scouts to his chestnut lodge in Little Switzerland, North Carolina. The memories of those idyllic mountain summers endure today in the minds of many. Farrens was so revered by these young men, many of whom grew up to hold prominent positions in Jacksonville, that in 1985 Mayor Jake Godbold issued a proclamation declaring June 24, 1985, Ross Farrens Day. (Both, courtesy of Thomas Reeves.)

A giant, unblinking, 20-foot-high orange T. Rex watches commuters speed past on Beach Boulevard. In days past, he lorded over an array of diminutive structures that made up the former Goony Golf complex. Back then, T. Rex's eyes used to blink, and he had a mechanical arm that operated a door to collect golf balls. Now his kingdom is a retail shopping plaza.

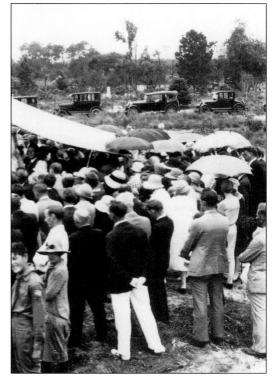

Here is a rainy-day funeral at Greenlawn Cemetery, probably photographed some time in the 1930s. Originally called the Dixie Pythian Cemetery, it was established in 1918 by the Dixie Pythian Lodge, an order of the Knights of Pythias. Over the years, the cemetery fell into disrepair, and it was purchased by a local funeral home and renamed Greenlawn Cemetery. In 1949, J. Howard Wendorph purchased the cemetery, retaining its name. (Courtesy of Thomas Reeves.)

One of the most beloved establishments in Jacksonville is Bono's restaurant. Now franchised throughout the country, the original building is the Bono's on Beach Boulevard, built in 1949. Sitting outside the restaurant are Harvey Green (left) and Joe Adeeb. Adeeb is the current owner and chief executive officer of Bono's, and Green, know as Harvey to all his customers, has been working at the Beach Boulevard location since 1957. (Courtesy of Joe Adeeb.)

Bono's began in 1943 when Lou Bono opened a seven-stool kiosk behind the stores in Times Square (the intersection of Atlantic Boulevard and Kings Avenue). Lou Bono developed his famous barbecue sauce based on a recipe used since 1924 by his friend Johnnie Harris of Savannah, Georgia. Lou Bono is seen on the right (center) at a barbecue celebrating the opening of the Mathews Bridge in 1953. The other men are unidentified. (Courtesy of the State of Florida Photographic Archives.)

A Jacksonville favorite, Patti's Restaurant was founded in 1951 by Peter and Mary Patti. At this time, Beach Boulevard was still unpaved, and it was quite a drive for many South Jacksonville residents. But it did not matter; people still flocked to Patti's. It was one of the first restaurants in Jacksonville to feature Italian dishes, and it also had white linen tablecloths, freshly baked bread, and a trained wait staff. Patti's closed on June 19, 1994, and many residents still mourn its passing. Below is another Beach Boulevard landmark, the Copper Top, formerly the Homestead. Originally a log cabin, the restaurant is known for its fried chicken, the 1940s recipe having been found in the attic. It is also reputedly haunted by the ghost of the original owner, Alpha Paynter, said to be the lady in white who sometimes appears on the second floor.

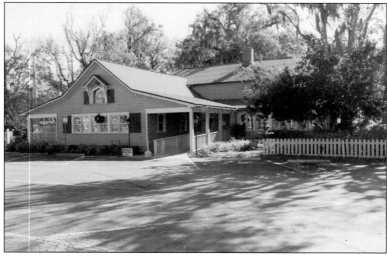

Taken inside the First Methodist Church in downtown Jacksonville, this photograph shows Louise Walker and Howell Andrews on their wedding day, May 27, 1939. Louise worked for the City of Jacksonville, and Howell worked for a variety of car dealerships, including Claude Nolan's. Their descendants still live on Jacksonville's Southside. (Courtesy of the Andrews family.)

This early 1920s photograph shows five-year-old Louise Walker posing with her hands folded and her ankles demurely crossed, as was expected of young ladies during this period. The large bow in her hair is a fashionable accessory characteristic of the period. Louise Walker was born on May 9, 1912. (Courtesy of the Andrews family.)

Julia Walker was photographed here in 1912. The white dress and locket were characteristics seen in many feminine portraits of the period. Note the beautifully rendered pleats on her skirt. The picture below shows Julia a few years later. Julia King was known as "Aunt Jude" to her relatives. She lived for many years on West Road, off Beach Boulevard near Hogan Spring Glen Elementary School. She also lived in the South Shores area between Bishop Kenny High School and the Channel 4 studios. She married Leslie King, and although they never had any children, she was a beloved aunt to her many nieces and nephews. (Both, courtesy of the Andrews family.)

This family portrait features Violet Alberta Walker Whitehead (left), her husband, Robert Henry "Bob" Whitehead, and their daughter, Marian Whitehead. They married on "Thursday, the Twenty-seventh of March," according to a newspaper account of the day. Violet graduated from Duval High School in June 1924. Violet is pictured as a toddler in Chapter One on page 11, sitting on a stuffed ostrich. (Courtesy of S. Andrews.)

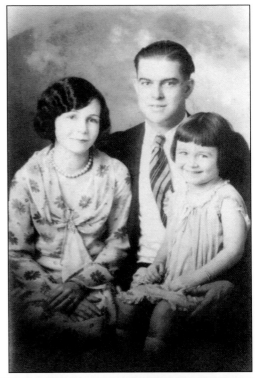

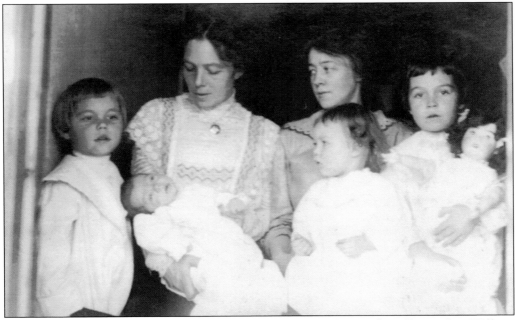

In this family gathering, the participants are, from left to right, Estill Walker, infant William Walker, Minnie Walker, Julia "Aunt Jude" King, toddler Louise Walker, and Violet Walker (holding a doll). A sad fact of life during this time period is illustrated here. William Walker died before his second birthday. (Courtesy of S. Andrews.)

It must have been a special occasion for twins Howell Andrews (left) and Herbert Andrews (right). They dressed up in suits and ties and brought wide-brimmed hats for the photograph. Perhaps, it was their birthday. The twins were born in Jacksonville in 1909, and many of their descendants still live on the Southside. (Courtesy of S. Andrews.)

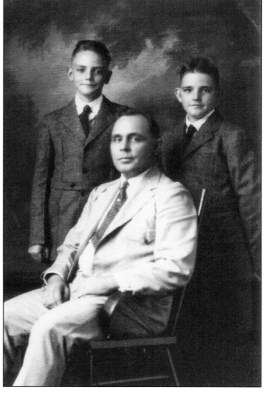

In this photograph, the twins Howell (left) and Herbert Andrews (right) are seen with their father, William Andrews. Judging by the background and general style of the picture, it appears to have been taken on the same day as the previous photograph, probably in the early 1920s. (Courtesy of S. Andrews.)

Six

THE FUTURE EVOLVES

SOUTHSIDE BOULEVARD, UNIVERSITY BOULEVARD, AND BEYOND

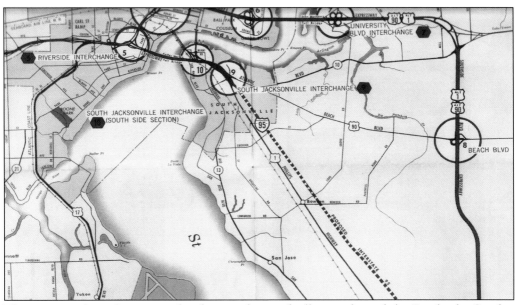

The map seen here documents the changes that gradually transformed the Southside. On this map, part of the Jacksonville Expressway System had been completed, and the route for "proposed Interstate 95" is marked by dotted lines. On the right is the "Southside Expressway." The Skinner family donated the land for this highway, now known as Southside Boulevard. (Courtesy of J. Waits.)

The iconic architecture of a Skinner Dairy Building (one of many Skinner family enterprises) is seen here. In 1901, Brightman Skinner was checking his turpentine traps when, suddenly, books, papers, picture frames, and pieces of cardboard began falling from the sky. It was May 3, and the city of Jacksonville, more than 10 miles away, was in flames. The conflagration was so intense and updraft so great that the debris from the fire was now raining down upon Skinner's head. He later visited the scene of devastation and witnessed the rebuilding of downtown. Decades later, when development began to move into the Southside in earnest, the Skinner family was ready. They had managed to hang onto their businesses and their land, 40,000 acres, through years of hard times. Now, they were in a position to help the growth of the Southside by donating land for roads, like Southside Boulevard, and projects, like the University of North Florida. And every Thanksgiving, members of the Skinner family gather in the woods to give thanks for the "Skinner Miracle" that allowed it all to happen. (Courtesy of Junius.)

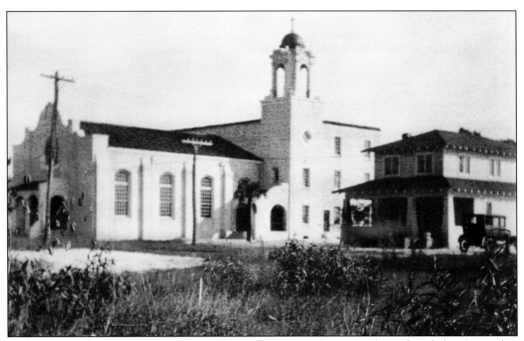

Southside Day School, known today as Jacksonville Country Day School, was founded in September 1960 and housed at the Swaim Memorial Methodist Church on Naldo Avenue in South Jacksonville (now San Marco). The first principal was Capitola Hopkins, and when the doors opened that first year, the school welcomed 80 students. (Courtesy of Jacksonville Country Day School.)

This photograph shows the new building located on Southside Boulevard. It was dedicated on September 27, 1964. The school was built on 10 acres of land adjacent to the Deerwood golf course and donated by the Deerwood Club, Inc. The school was capable of accommodating 200 students and was fully air-conditioned. (Courtesy of Jacksonville Country Day School.)

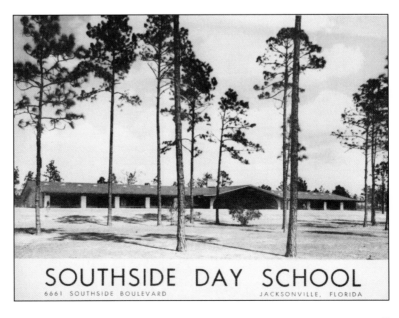

SOUTHSIDE DAY SCHOOL
6661 SOUTHSIDE BOULEVARD JACKSONVILLE, FLORIDA

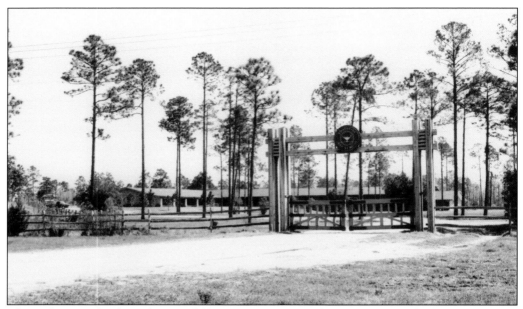

These photographs show the two different entrance gates leading into Southside Country Day School. They also document the gradual evolution of the school's name. The circular plaque over the unique entrance above reads "Southside Day School." The picture below depicts new gates and the new name, Southside Country Day School, which was changed in 1971. The name was altered again in 1974 to its current title of Jacksonville Country Day School. The brick gates seen below are still visible today on Southside Boulevard, minus the sign, but the school's entrance is located around the corner on the north side of Baymeadows Road. (Both, courtesy of Jacksonville Country Day School.)

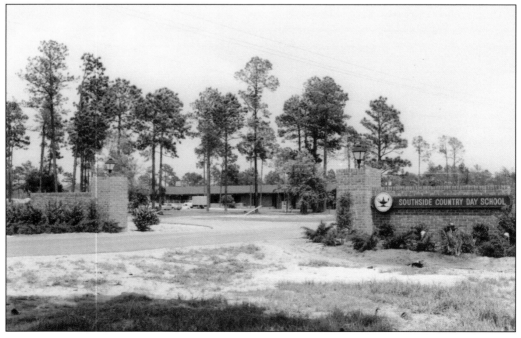

Despite its vintage appearance, the Twistee Treat structures and franchise were created in 1983 in North Fort Myers, Florida. The distinctive 20-by-20-foot buildings were made of fiberglass and shaped like a huge cone of soft-serve ice cream. The Twistee Treat on University Boulevard is being reborn in this picture as a cupcake business, and the building is being retrofitted with corrugated metal to transform the ice cream cone into a cupcake. (Courtesy of Junius.)

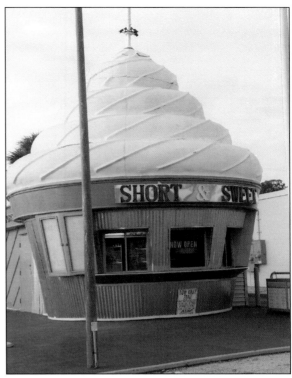

This 1940s photograph shows Edith Peterson and her brother Philip Peterson standing in an undeveloped area off University Boulevard (then called Love Grove Road). Today, this piece of land is home to Love Grove Elementary School. The name was changed to University Boulevard because of Jacksonville University's location on the northern end in the Arlington area. (Courtesy of the Peterson family.)

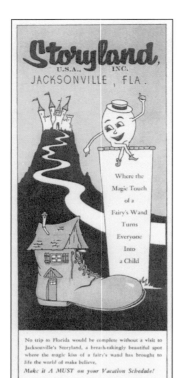

This brochure is from the theme park Storyland U.S.A., located a quarter-mile east of the Matthews Bridge on US 90 Alt (Arlington Expressway). Its 10-acre site included a "Storyland Trail" with scenes taken from fairy tales. It also had rides including a Ferris wheel, riverboats for cruising the St. Johns River, and a "tiny roller coaster no higher than your head." It was put up for sale in May 1958. (Courtesy of Lostparks.com.)

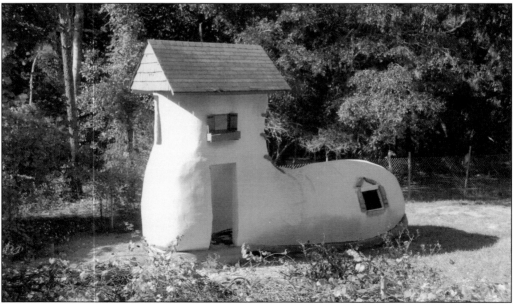

Today, one well-traveled 38,000-pound concrete artifact remains from Storyland U.S.A. When Storyland U.S.A. closed, the shoe crossed the St. Johns River to reside at a skating rink on Lem Turner Road. Years later, it moved to Dan Beard Photography in the Normandy area. Finally, it crossed the river once again. Now, it rests at B.E.A.K.S. bird sanctuary on Big Talbot Island, where it is used in early learning programs. (Courtesy of Junius.)

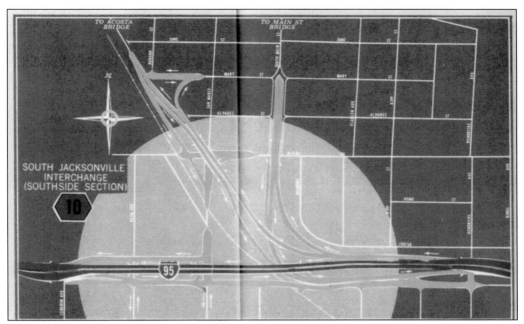

Nothing changed the face of Jacksonville's Southside more dramatically than the building of Jacksonville's first expressway. Entire blocks of homes and businesses were eliminated, buildings razed, and traffic patterns forever altered. The map above shows the South Jacksonville interchange (Southside Section). (Courtesy of J. Waits.)

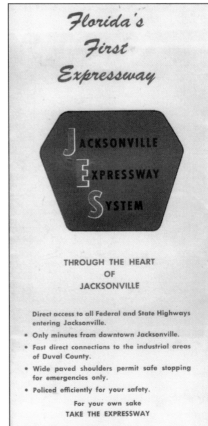

This image is taken from an early brochure that proudly advertised the new interstate as "Florida's First Expressway." The text extols the highway's many benefits that included "wide paved shoulders" and efficient policing. Finally, it implores the following to the reader: "For your own sake, take the expressway." (Courtesy of J. Waits.)

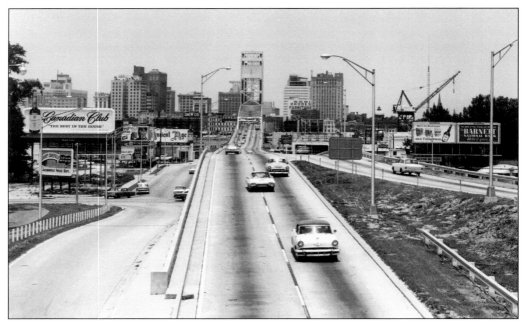

This photograph was taken soon after the new expressway opened. The Main Street Bridge (John T. Alsop Bridge) is clearly visible in the distance. Compare this photograph to the one on page 29. Although this picture presents a view that is slightly closer to the bridge, the change in the landscape produced by the building of the highway is clear. (Courtesy of the State of Florida Photographic Archives.)

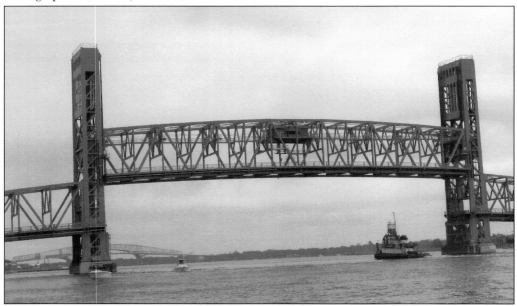

The Main Street Bridge (John T. Alsop Bridge) is seen here in its raised position. John T. Alsop, for whom the bridge is named, served as mayor of Jacksonville from 1923 to 1937 and then again from 1941 to 1945. The bridge opened in July 1941. In this photograph, the bridge in the distance is the Hart Bridge, which opened in 1953.

At the southern end of Duval County, the rural nature of the area existed well into the 1970s. This photograph was taken in 1956 and shows San Jose Boulevard (State Road 13) at its intersection with Loretto Road. The service station on the right was owned by Braddy Wilford, and the property is owned by the Wilfords today. On the right side of the picture is entrance to the Mandarin train attraction. (Courtesy of the State of Florida Photographic Archives.)

This is a photograph of the aftermath of demolition along Atlantic Boulevard and Minerva Street, looking north. In the early part of the 21st century, a one-block area was completely razed in preparation for the planned development called San Marco East. The buildings that succumbed to the wrecking ball included a strip shopping center, a gas station, a florist shop, and a large branch bank.

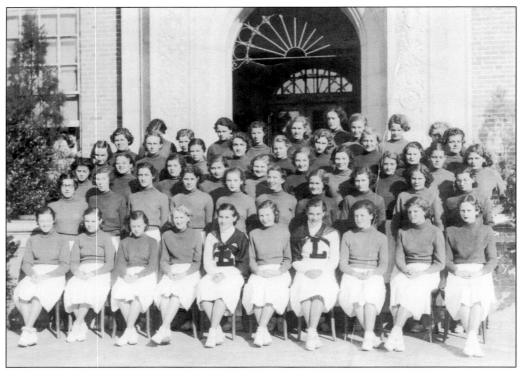

The Landon Lionettes are posing here on the front steps of Landon High School. The exact year is unknown, but it is an early photograph, possibly taken some time in the 1930s. The students are unidentified. The picture below shows the 1940–1941 Landon Lionettes and also testifies to a significant increase in their numbers. These two pictures demonstrate how change is a constant not only in buildings, landscapes, and roadways but also in small things like uniforms. Many photographs of the Landon Lionettes can be dated according the style of uniform they wore. (Both, courtesy of the Landon Alumni Association.)

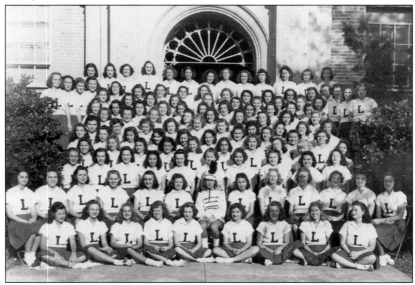

Changes continue to occur on the Southside. This is a photograph of the demolition near the corner of Hendricks Avenue and Atlantic Boulevard. The building seen here housed many small businesses over the years, including a Chinese restaurant, a consignment shop, and a dance studio. The structure was torn down in preparation for the new San Marco East development.

A flyover of the "People Mover" is seen here at the intersection of Flagler Avenue and Mary Street. The People Mover carries commuters from the Southside to various destinations in downtown Jacksonville, adding yet another way to cross the St. Johns River. This intersection is the site of a piece of lost history, Dixieland Park. The land beneath the parking garage (visible behind the building) was once home to the large Dixieland Theater Building.

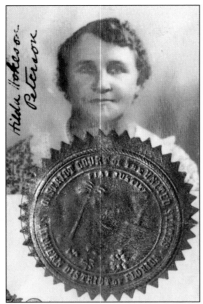

This is a photograph from Hilda Peterson's citizenship document. Hilda waited many years to regain her citizenship after losing it when she married, due to the laws of the day. She had gained citizenship originally as a teenager when she came to the United States from Sweden to live with her father. This document was discovered tucked away in a yellowed envelope. Nestled within its folds was a small, carefully preserved American flag. (Courtesy of the Peterson family.)

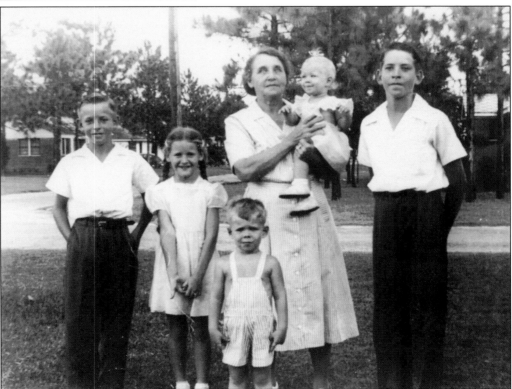

Hilda Peterson was photographed on the corner of Peachtree Street and London Road in the 1950s posing with her grandchildren. The children are, from right to left, Ken Peterson, Becky Peterson, Howard Vollers, baby Barbara Vollers, and John Peterson. Note Howard Vollers's jumpsuit, made from the same striped fabric as Hilda's dress. (Courtesy of the Peterson family.)

From its early beginnings as the first structure to span the St. Johns River to the present day, this long finger of rail line still rolls through the Southside. From the 1920s until the 1960s, the area of track pictured here was a bustling hub that served many passenger trains. The South Jacksonville station building was located here, and this site near Hendricks Avenue harbors many memories, from vacationing tourists to returning soldiers. It was even the scene of a train wreck so devastating that the event was reported in the *New York Times*. The station building is long gone now, having been torn down in the 1970s, but the railroad is still actively used by freight trains—freight trains that continue to rumble on, transporting the materials and goods that support development and help bring new changes to Jacksonville's Southside.

Discover Thousands of Local History Books
Featuring Millions of Vintage Images

Arcadia Publishing, the leading local history publisher in the United States, is committed to making history accessible and meaningful through publishing books that celebrate and preserve the heritage of America's people and places.

Find more books like this at
www.arcadiapublishing.com

Search for your hometown history, your old
stomping grounds, and even your favorite sports team.

Consistent with our mission to preserve history on a local level, this book was printed in South Carolina on American-made paper and manufactured entirely in the United States. Products carrying the accredited Forest Stewardship Council (FSC) label are printed on 100 percent FSC-certified paper.

MADE IN THE
USA